THEN & NOW

ARLINGTON

Opposite: The Middlesex Sportsmen's Association often set-off on gamebird-hunting expeditions in the hills of Morningside from YousaY cottage on Mystic Street. This image was made around 1910. (Robbins Library.)

THEN & NOW

ARLINGTON

Richard A. Duffy

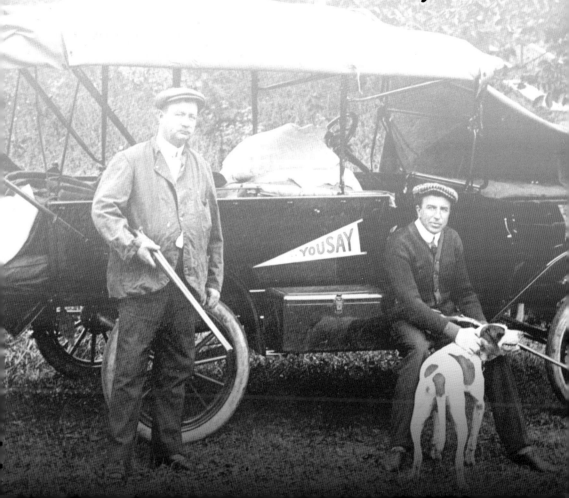

*To honor a decade of cordiality and collaboration in my many works
on the history of Arlington, this book is respectfully dedicated to
Jennifer DeRemer, head of adult services at Robbins Library, and to
William H. Mahoney—"The Patriarch."*

Copyright © 2006 by Richard A. Duffy
ISBN 978-0-7385-4542-4

Library of Congress control number: 2006923345

Published by Arcadia Publishing
Charleston SC, Chicago IL, Portsmouth NH, San Francisco CA

Printed in the United States of America

For all general information contact Arcadia Publishing at:
Telephone 843-853-2070
Fax 843-853-0044
E-mail sales@arcadiapublishing.com
For customer service and orders:
Toll-Free 1-888-313-2665

Visit us on the Internet at www.arcadiapublishing.com

On the front cover: C. G. Sloan's Boston Branch grocery occupies the ground floor of Union Hall, about 1898. The upper-story auditorium was a multipurpose religious and community gathering place when Arlington Heights was in its infancy. The *c.* 1876 Carpenter Gothic structure at 41 Park Avenue has been beautifully restored by Arlington Coal and Lumber. The automobile in the modern view is a 1995 Buick Riviera. (William H. Mahoney collection.)

On the back cover: In 1852, B. F. Woods built a tide mill on the Mystic River for wood turning and the manufacture of baby carriages. His mill dam was removed in 1872, after being declared an obstacle to the passage of pleasure boats. Arlington novelist J. T. Trowbridge based *The Tinkham Brothers' Tide-Mill* on these real-life struggles. The book became a best seller in 1882, making the semi-abandoned mill a local tourist attraction. It was destroyed by arson in 1891. (Medford Historical Society.)

CONTENTS

Acknowledgments vii
Introduction ix

1. East Arlington 11

2. Arlington Center and Vicinity 29

3. Arlington Heights 67

4. Mysticside 83

ACKNOWLEDGMENTS

I gratefully acknowledge the many individuals and organizations whose generosity, flexibility, and interest in this book helped to bring it to fruition.

My neighbor Jeanne Meister has been a most enthusiastic supporter of this project, and images from her collection of photographs taken in 1925 by William Hynes made a major contribution to this volume.

When my "day job" is over, and I am heading to my unofficial duties as town-historian-by-night, the adult services librarians at Robbins Library certainly brighten this "second shift." Special thanks to Jennifer DeRemer, head of adult services, and to Ellen Wendruff, who has recently assumed management of the Local History Room.

My fellow members of the Arlington Historical Society (AHS) have always provided a strong base of support. My thanks go to the directors and trustees, with extra appreciation to museum administrator Doreen Stevens. Bill Mahoney is someone that no one working on a photographic history should be without. Several images in this book were supported by a grant to the society by the Massachusetts Cultural Council, administered by the Arlington Cultural Council; I am grateful for the efforts of Carol Mahoney to secure this funding.

Others who have lent me much valuable support include Grace Dingee and Ray Lum of the Old Schwamb Mill; Mary Gallant of the Medford Public Library; Michael Bradford and Jay Griffin of the Medford Historical Society; John Cronin of the Boston Herald; Jim Shea and Alan MacMillan, fellow Friends of Bedford Depot Park; the Walker Transportation Collection of the Beverly Historical Society and Museum; Mark Wanamaker; Charles S. Morgan; Paul Hogman; Joel Hall; Delia R. Alonso; and Patsy Kraemer of the Town of Arlington.

The loving support of my parents, Richard L. Duffy, and the late Shirley Stowell Duffy, is present throughout this book—in ways both visible and unseen. Barbara and Ken Matheson have inspired me over and again to continue to make the historical connections that help to bring extra life to the images in my books and in my illustrated lectures.

José M. Rodríguez was an invaluable part of this project. He manned the scanner, helped me to tie loose ends, and patiently listened to the smallest variations that I could dream up for every page of this book—thank you, always and for everything.

INTRODUCTION

In 2007, Arlington celebrates its 200th anniversary as an independent town. This book is presented on the eve of the bicentennial to capture, in a visually compelling way, many aspects of change in both its built and natural environments. I hope that it will enhance our knowledge of how the places that are familiar to us came to be and inspire a deeper appreciation for the past.

Arlington was settled by the English in 1635. Most of its present-day territory was part of Cambridge. The Morningside neighborhood and the section of East Arlington roughly north of Broadway belonged to Charlestown. It was a sparsely populated area that extended into present-day Winchester and was referred to as Charlestown End.

An informal village, known by the American Indian name of Menotomy, developed over the next century. Its inhabitants were granted semi-autonomous status in 1732 as the Northwest Precinct (or Second Parish) of Cambridge. Massachusetts was governed largely as a theocracy, so approval to build a local Congregational meetinghouse and settlement of a minister were traditional first steps towards municipal independence.

The name Menotomy persisted in common, if unofficial, use after the new precinct was established. It was always a confusing word to outsiders. On April 19, 1775, British lieutenant William Sutherland, who survived the bloodiest fighting on the first day of the American Revolution, famously remarked how the troops had been "most annoyed at a Village called Anatomy." By 1807, the precinct had grown to a population of 900 and had remained almost entirely rural, which put its interests increasingly at odds with those of rapidly developing Cambridge. Thus the "mother town" supported the petition for the Northwest Precinct to become separately incorporated as the town of West Cambridge. Charlestown End was annexed to West Cambridge in 1842.

Some leading residents sought for West Cambridge to be more readily identifiable as an independent town and not be confused with any section of Cambridge. The Massachusetts legislature approved reincorporating the town as Arlington in 1867. The U.S. Civil War had recently ended, and the new name honored the soldiers buried at what would become Arlington National Cemetery in Virginia.

From earliest settlement by the English, Arlington began to undergo dramatic changes. By 1637, its first of a chain of artificial ponds was created by the damming of Mill Brook near the corner of today's Mystic and Summer Streets, thus putting into operation the first gristmill in the vicinity. In 1655, an earthen causeway was built across the Mystic River, just above its confluence with Alewife Brook, to carry a portion of the "county highway" from Harvard Square to Winchester Center. The structure doubled as a dam for tide mills that not only ground corn but also treated home-loomed cloth in a process known as fulling.

As throughout much of Greater Boston, deforestation proceeded at a rapid pace in the 17th and 18th centuries. Trees were cut to provide timber for construction and fuel, and to clear fields for agriculture. When Arlington began to develop as a residential suburb in the second half of the 19th century, ornamental shade trees began to reappear in great numbers. The abundance of mature vegetation that characterizes Arlington today often poses a special challenge when

attempting to capture modern images from the same angles as antique photographs featuring comparatively open landscapes.

This book is organized by geography. There being no official demarcations for the sections of town named in the chapters, images were placed where best indicated by traditional usage, centers of commerce, and the more official territorial bounds of schools and churches. Within this geographic arrangement, the images are organized as if the reader were being led on a walking tour, with the inevitable occasional backtracking or detour to encompass places of particular interest that are not on the most direct route.

Not surprisingly for a formerly rural community, most of the early photographs depict places in the center of town; thus "Arlington Center and Vicinity" is by far the largest of the four chapters. The historical images also tend to cluster, from East Arlington through Arlington Heights, along Massachusetts Avenue. Mysticside, the traditional name of the area along the Mystic River and Lakes from the Medford Street Bridge to the north, was the most thinly settled part of town and that was where the last of the large market gardens were located. In recent years, the Mysticside name has largely given way to calling the entire section "Morningside," a real estate development whose name expanded far beyond its original borders—in the same way that Arlington Heights came to be applied to most of the hilly territory on either side of the railroad tracks in the western part of town.

Some comments on the modern photographs will be helpful to understand them in relationship to the vintage images. All were made by the author in digital format, from February through May 2006. Whenever possible, the same angle of view was used as in the old photograph; however, this book is not intended to be an exercise in reproducing antique optics, or capturing precise geographic points at two moments in history. In many instances, buildings, fences, evergreen plantings and other visual obstructions required that the scene be shot from a different angle. In other cases, failing to adapt to modern conditions would have yielded uninteresting images of "could-be-anyplace" stretches of asphalt, or trash cans behind a garage.

In order to hit the target, but not miss the point, the main features of the modern views are shown in their entirety. Alternatively, in cases where transparent views across open fields of crops are no longer possible because entire neighborhoods have taken their places, emblematic images of the vicinity were chosen. The Bishop School on the former Crosby farm, and the entrance to Kelwyn Manor on the old Franklin Wyman farm, are two examples of this approach.

Lastly the vintage images chosen in this book have not been published in either of my two photographic histories of Arlington in the Images of America series. Each "then" photograph has been selected to offer something different, even to the most devoted students of Arlington history. The pairings of before and after images were selected to show the depth and breadth of transformations in Arlington through the centuries—to pique the interest and stimulate the thinking of all readers who enjoy learning about how places change over time.

CHAPTER 1

EAST ARLINGTON

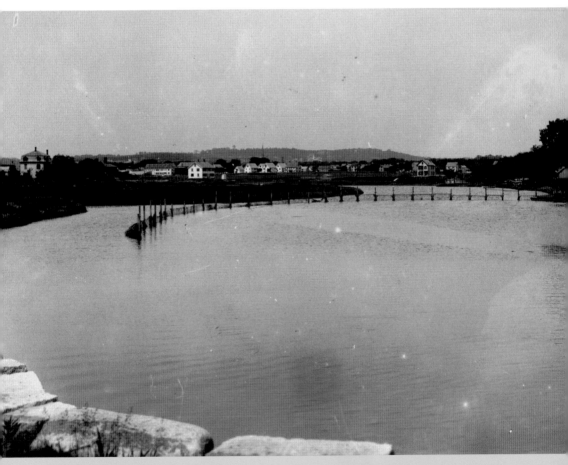

This is an unusual view of East Arlington, taken around 1890 near the confluence of the Mystic River and Alewife Brook. Note the fishing weirs in the river for the spring catch of alewives, a type of herring. The white mansard-roofed house at left is still standing at 89 Decatur Street. Arlington Center is in the distance. (Medford Historical Society.)

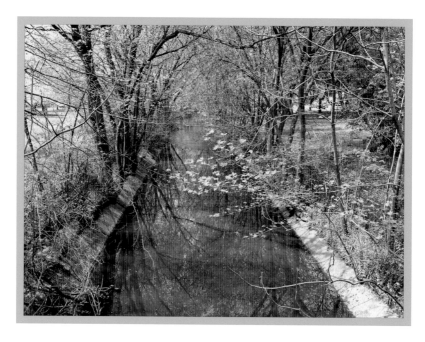

This *c.* 1895 view of Alewife Brook looks towards Belmont. Although the marshes along the former tidal river were scenic, they were often polluted by tannery waste and sewage from Cambridge. The fouled area became a major breeding ground for mosquitoes and led to malaria epidemics that affected the majority of homes in the nearby Hendersonville neighborhood. The river was channeled and became an exclusively fresh-water stream in 1910. Sewage from Cambridge, first complained about by Arlington officials in 1879, remains a problem over 125 years later. (Robbins Library—RL.)

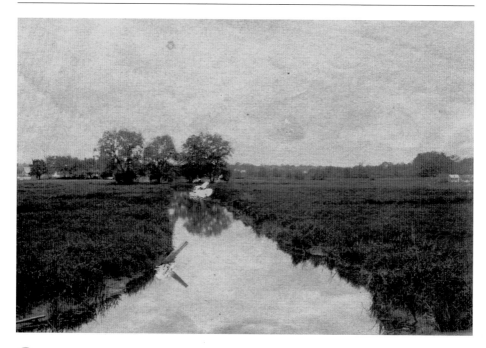

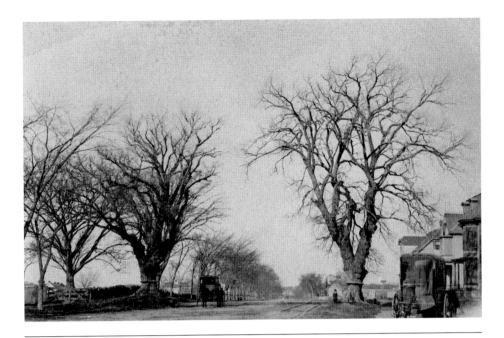

This *c.* 1880 view, looking west down Massachusetts Avenue, features the ancient elms that created a gateway from Cambridge into Arlington. The stately trees had died by the early 20th century, but their image endures in Arlington's town seal. Some of the houses of "Hendersonville," surviving today, can be seen at right; they flank Teel Street. Note the single set of horse-streetcar tracks laid along the side of the road. Although the open fields are entirely filled in today, the modern view seems comparatively empty. (Arlington Historical Society—AHS.)

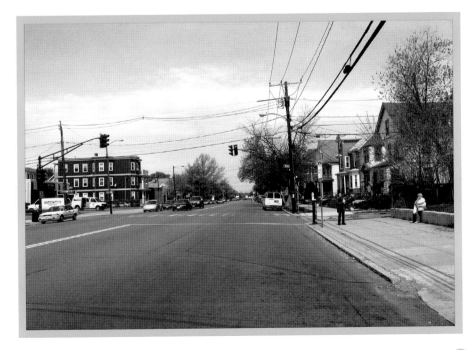

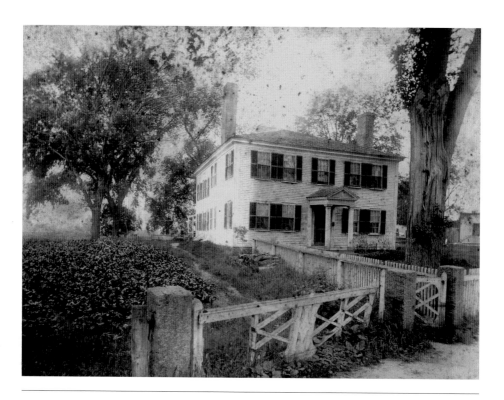

The mid-18th-century home of Jonathan Whittemore at 54 Massachusetts Avenue is one of the rare survivors of Arlington's Colonial-era architecture. It was the first house beyond the brackish marshes of the Alewife Brook, then known as the Menotomy River. It has been squeezed by 20th-century development on either side, but will be given a new lease on life as it undergoes restoration by Richard Johnson. (AHS.)

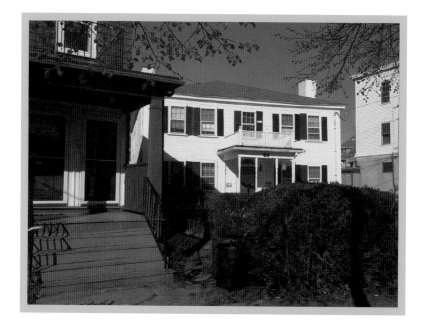

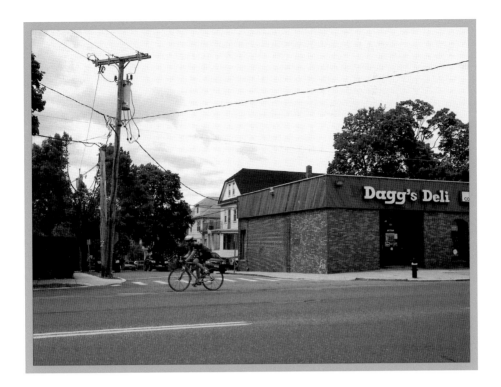

This view of Melrose Street epitomizes the transition taking place in East Arlington in the 1920s: construction of two-family houses at an almost breakneck pace, with streets dead-ending from Massachusetts Avenue into active farmlands. The beet fields in the background would soon surrender to the irresistible increase in land values and Melrose Street literally pushed itself southward. (William H. Mahoney collection.)

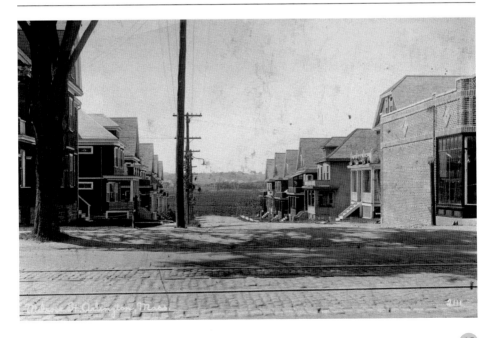

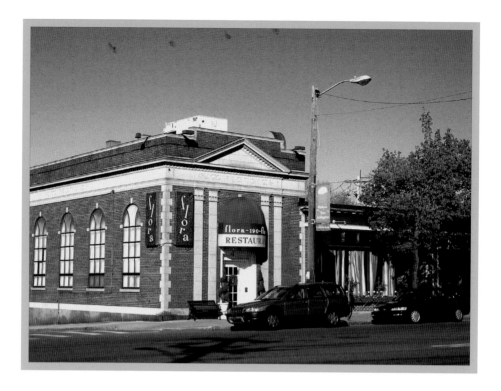

The East Arlington branch of the Arlington Five Cents Savings Bank opened in 1924 at the corner of Massachusetts Avenue and Chandler Street. It was substantially remodeled several years later to become the "anchor" of the commercial block, rather than a mere storefront. Note the neighboring business: "Miss Armstrong, Real Estate." Since 1996, the former bank has been home to the popular gourmet restaurant, Flora, where the vault now serves as a private dining room. (Jeanne Meister collection.)

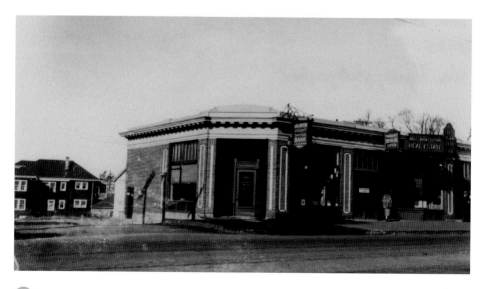

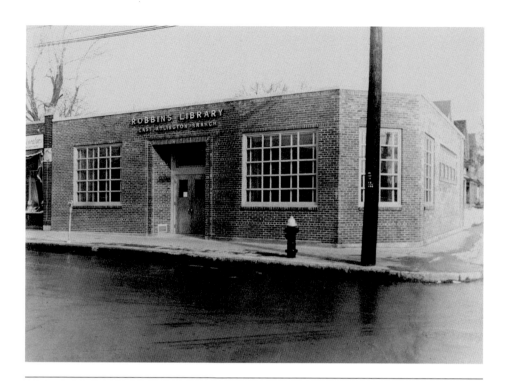

Robbins Library once had branches in Arlington Heights (first located in part of the Locke School) and in East Arlington, where it chose a prime location at the corner of Massachusetts Avenue and Cleveland Street. Its original architecture had all the allure of a penitentiary, and it was given a more cheerful remodeling when it was rededicated in 1969 to honor benefactor Edith M. Fox. Neighborhood residents have successfully fought for decades to keep this vital library and community center open. (RL.)

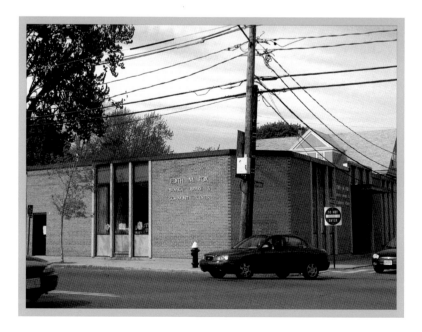

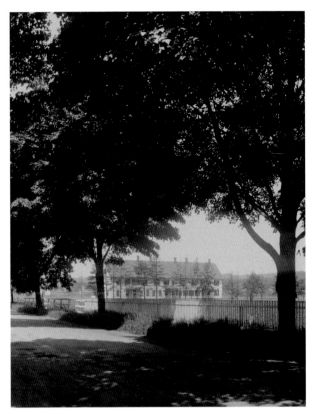

This block of six attached dwellings was located on Wyman Lane, which ran into the fields of the Franklin Wyman farm on Lake Street. It housed laborers and teamsters, mostly Irish immigrants, who worked year-round at the farm, focused on maintaining acres of greenhouses. During field-harvest time, Italian immigrant women came each morning by streetcar from Boston's North End to supplement the workforce. In 1938, the Franklin Wyman farm was subdivided to create Kelwyn Manor, which later established a neighborhood association for the single-family enclave. (RL.)

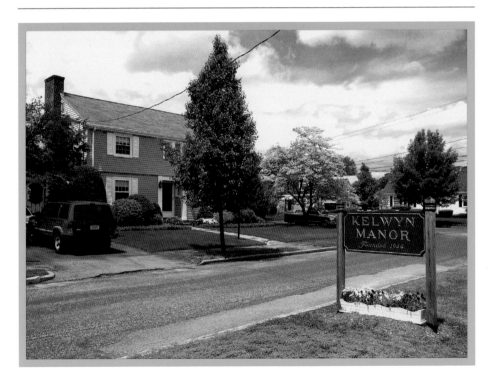

Tremendous growth in East Arlington and adjacent Belmont led to the establishment of St. Jerome's Roman Catholic parish, whose simple Romanesque-influenced church opened in 1935 at 197 Lake Street. St. Jerome's was among three of the six Catholic parishes serving Arlington to be "suppressed" in a wave of closures in 2004. The others, St. James, in Arlington Heights, and Immaculate Conception, in North Cambridge, were spared the wrecker's ball. A new home now stands on the site of the sanctuary, but the 1938 rectory fortunately was preserved. (Boston Herald.)

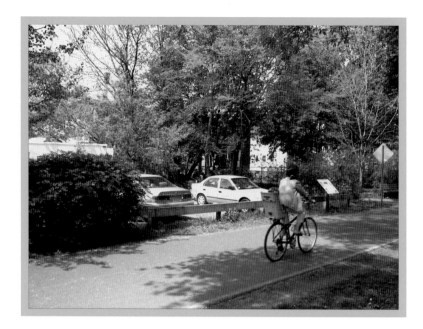

Lake Street (originally Weir Lane) station served as a passenger and express depot. The station name was once spelled out across a prize-winning flower bed. By the 1930s, it had become a neighborhood convenience store. Lake Street and Arlington Center were the two surviving of four stops in Arlington when passenger rail service was discontinued in 1977. Today the site is a small parking lot, serving the Minuteman Bikeway that replaced the rail line. (Beverly Historical Society and Museum.)

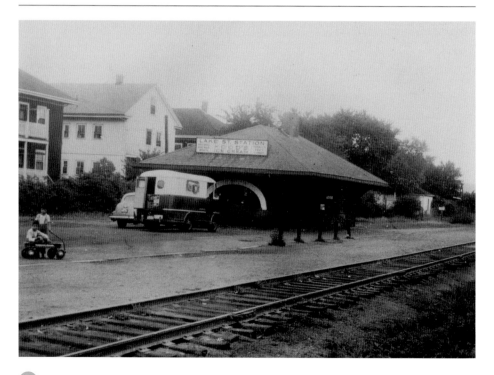

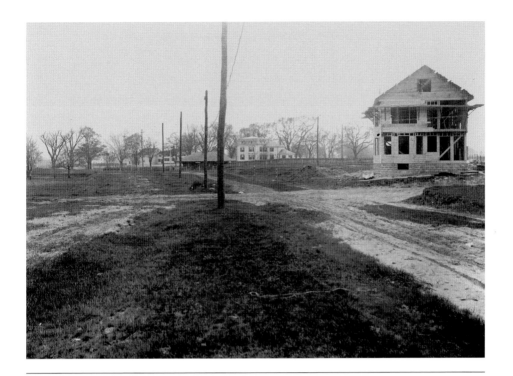

This 1915 view shows a two-family house under construction at the corner of Newcomb Street and Orvis Road, in the newly subdivided John P. Squire estate. The old Lake Street railroad station is visible in the rear. The white mansard-roofed building beyond it was the home of Josiah Crosby; it still stands at 85 Lake Street. The modern view shows that the neighborhood quickly filled in with other homes. Orvis Road, with its landscaped median, is listed on the National Register of Historic Places. (RL.)

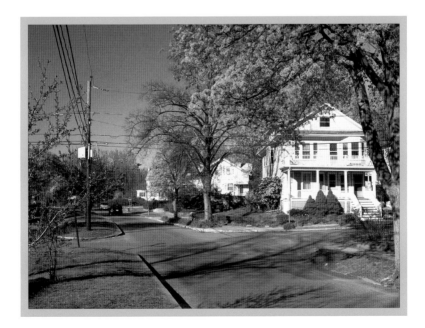

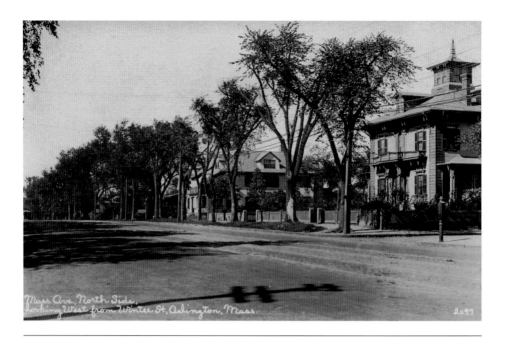

Mass Ave, North Side, Looking West from Winter St, Arlington, Mass. 2097

In the mid-1800s, Samuel W. Hill had both his home and gentlemen's neckwear factory located at the western corner of Main and Union Streets, today's Massachusetts Avenue and Winter Street. By the middle of the 20th century, it had become the residence of Dr. Henry DeRoche, a dentist who practiced in West Somerville. The Summit House high-rise apartment block replaced the grand Victorian home in the 1960s. (William Mahoney collection.)

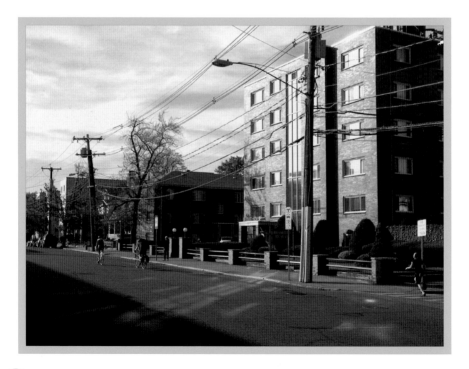

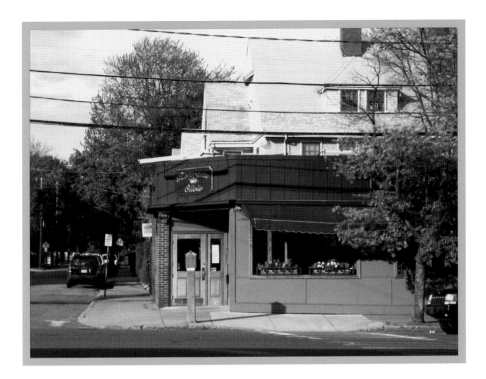

The Angus Drug Store, an independent pharmacy that was part of the Rexall association, operated in the mid-1920s at the eastern corner of Massachusetts Avenue and Winter Street. The "college ices" advertised on the awning are what would be called ice-cream sundaes today. Ever since beer-and-wine licenses were granted in Arlington starting in 1994, many small restaurants have been attracted to town, among them Ristorante Olivio. (William H. Mahoney collection.)

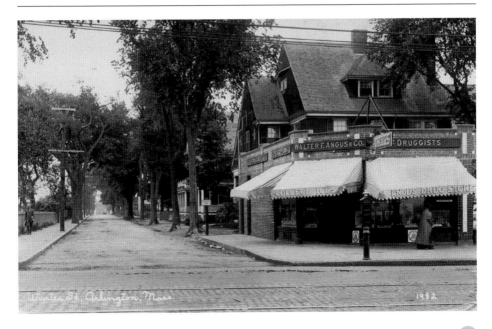

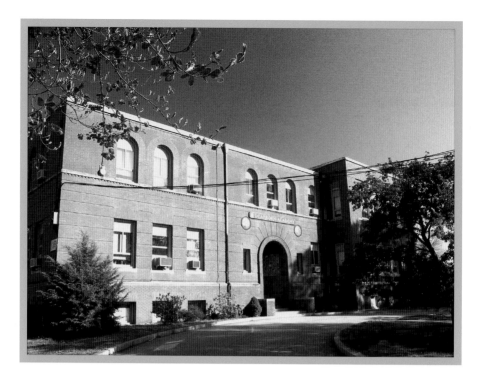

The brick Crosby School on Winter Street was built in 1896. This 1925 photograph was taken shortly after massive expansion of the building to the right of the arched main entrance. The stylistically incongruous pediment at the roofline distinguishes the addition from the original building. The top floor was removed following a 1953 fire, drastically reducing its late-Victorian character. After the Crosby School closed in the early 1980s, it became home to Dearborn Academy, a private day school serving special needs children and adolescents. (Jeanne Meister collection.)

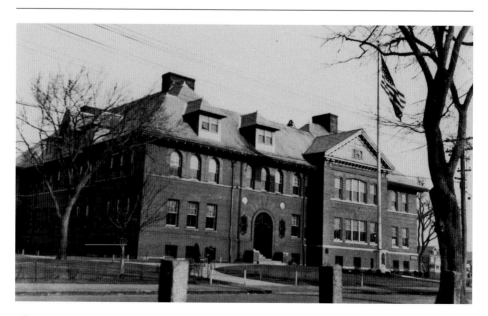

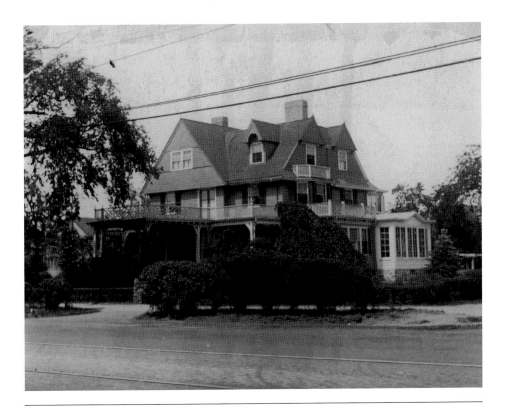

The grand home of William and Kate Squire Muller was built at 231 Massachusetts Avenue upon their marriage in 1893. It was diagonally across the street from Mrs. Muller's childhood home, the John P. Squire house. William Muller was a successful Boston insurance agent who served in many elected and appointed town offices. The home and its carriage house were converted to multifamily use in the late 1940s and moved to the east side of Grafton Street, just behind the banal brick apartment block that took its place. (RL.)

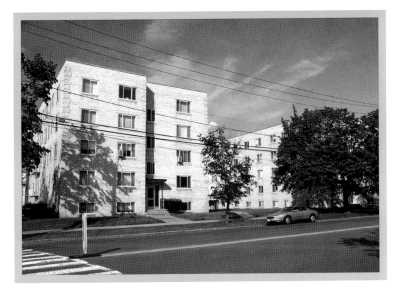

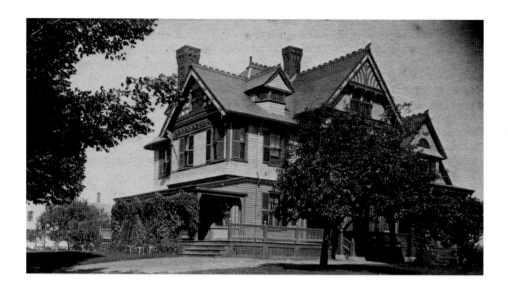

The mansion-house of George Dwight Moore was built in 1884 at 181 Broadway, from where his market gardens extended all the way to the Mystic River. The farm won statewide prizes for many vegetables, including little-remembered salsify. Moore's hothouse-grown cucumbers were another trademark crop. Moore was also the developer of Arlington's earliest apartment houses. His son, M. Ernest Moore, sold the farm for residential subdivision, and tore down the family home in 1950 to make way for the garden apartment complex shown in the modern view. (Charles S. Morgan collection.)

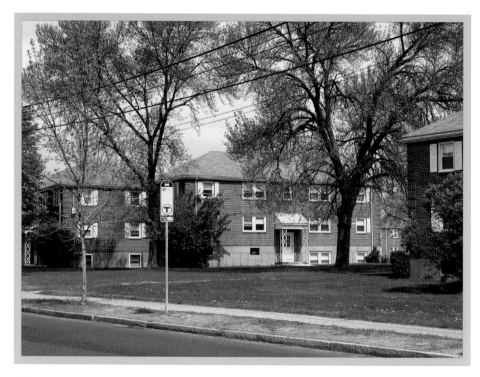

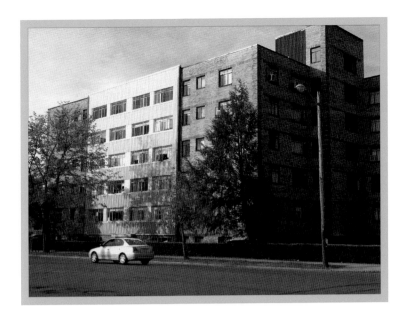

The gas street light in front of the George Peirce home on Massachusetts Avenue indicates the easternmost limit of the utility grid. George Peirce is credited for establishing the first "scientific" celery bed on the Spy Pond banks of his farm, and his Williams apples (a local heirloom variety) were famous in Boston. In 1908, the house was dismantled and moved to create worker housing on the Lyons farm. In the mid-1950s, a high-style multi-hued brick and aluminum faced apartment block went up on the site. (AHS.)

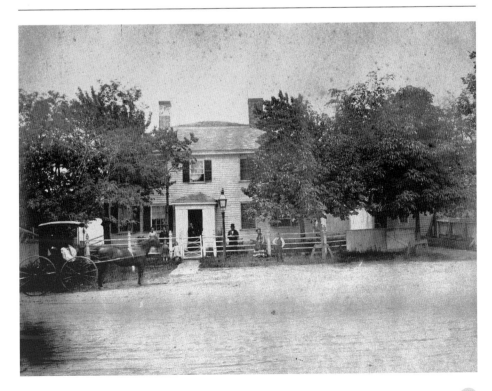

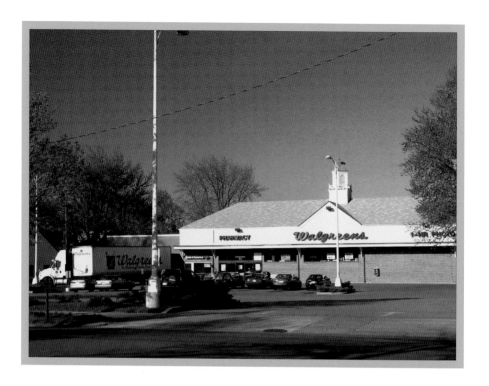

The Reed Dodge and Plymouth automobile dealership was one of many that lined Arlington from the east to the heart of the center. This vintage image dates from 1948. In the early 1960s, the building was torn down to make way for an A&P supermarket, which today is a Walgreen's pharmacy. The placement of the building at the rear of a parking lot, rather than along pedestrian-friendly sidewalk frontage, is an unfortunate aspect of automobile-over-people design. (William H. Mahoney collection.)

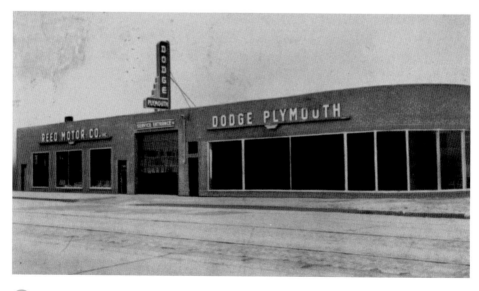

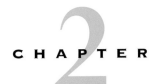

ARLINGTON CENTER AND VICINITY

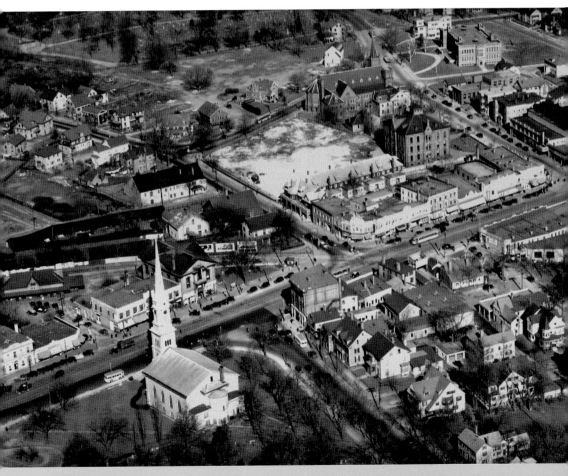

This *c.* 1931 view of the center shows many aspects of "lost Arlington": the 1856 Unitarian Church; the railroad depot, the long series of coal sheds belonging to Peirce and Winn; Russell Park, paved for parking in 1959; and the pre-1960 junction of Mystic Street and Massachusetts Avenue. (RL.)

29

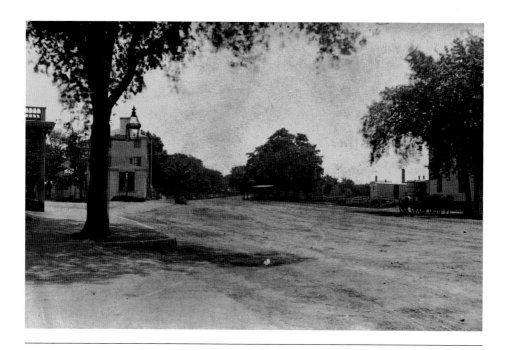

This *c.* 1875 view looks east from the corner of Medford Street, towards the junction of Charlestown Street and Arlington Avenue (today's Broadway and Massachusetts Avenue, respectively). The gas lantern stands near the corner of the 1826 Arlington House Hotel, razed in 1925 for the commercial block that now houses Starbucks. The Civil War monument (erected 1887) is a bit lost in the background of the busy modern view of the sidewalk-café ambiance on Broadway Plaza. (RL.)

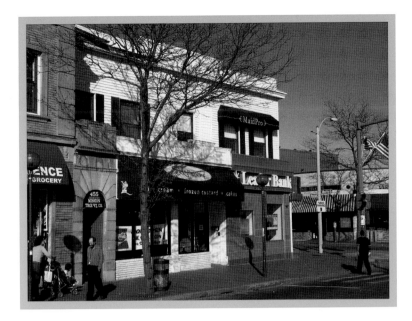

This *c.* 1860 view shows the Masonic Block located on the northwest corner of Massachusetts Avenue and Medford Street. The first floor was occupied by retail tenants, and the upper two stories were used as the Masonic lodge. A one-story expansion of ground-floor shops wrapped around the building in 1914, and the third floor was destroyed by fire in 1923. This building survives, obscured by an unsympathetic blend of exterior building fabrics and styles. Leader Bank, headquartered in Arlington since its establishment in 2002, anchors the corner. (AHS.)

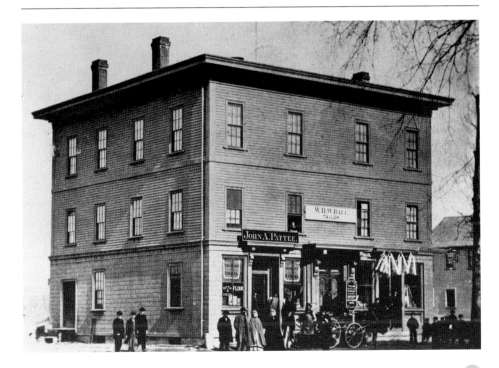

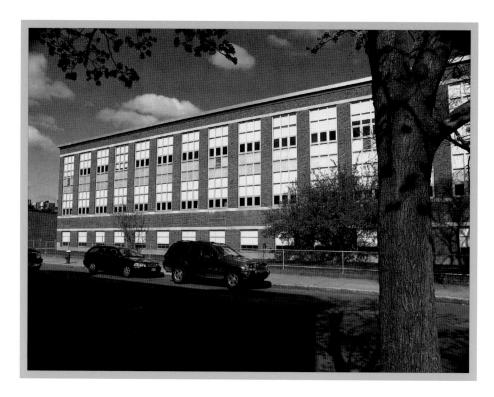

The Russell School, a grammar school, was built in 1873 to replace a much smaller wood building that had been lost to fire. It closed in 1956, after the Francis E. Thompson Elementary School opened. The Russell School's two lower floors were incorporated into the rear of the 1960 Arlington Catholic High School shown here, whose construction led to the demolition of the *c.* 1845 home of merchant Charles Cutter, adjacent to the Russell School. (Jeanne Meister collection.)

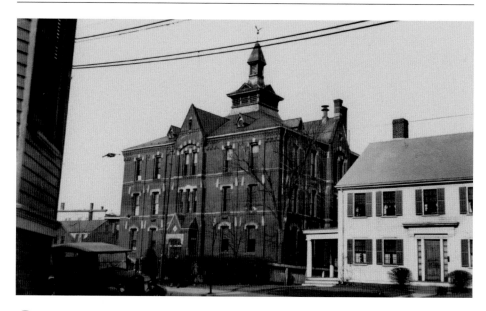

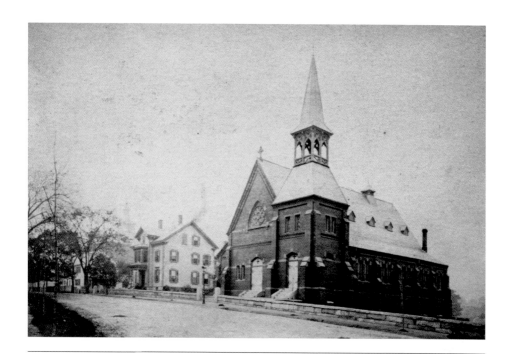

This "cabinet card" view of St. Malachy's Roman Catholic Church (built 1870) possibly was made to show the recent construction of the 1879 rectory next door. Note the gas street light in front of the church. The parish originally served Arlington, Belmont, Lexington, and Bedford. It was enlarged and rededicated to St. Agnes in 1900. The rectory burned in 1996, replaced by a functional brick building of little architectural interest. (Joel Hall collection.)

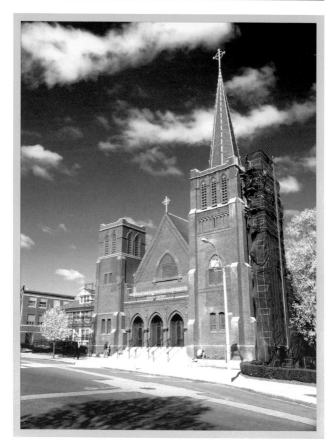

In the 1920s, the three-story Swan's Block was demolished and replaced with a one-level building that was the 475 Massachusetts Avenue home to Shattuck's Hardware. Multi-story commercial blocks clustered in the center were becoming obsolete as development of the town literally spread out from east to west in the early decades of the 20th century. The building still stands, minus its decorative cast-concrete facing and parapet. These roofline embellishments are typically the first to vanish as a building ages. (AHS.)

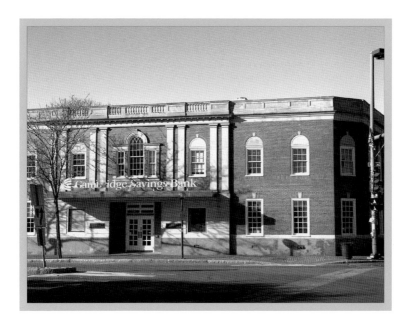

This 1874 building was the first brick commercial block in Arlington. In some ways it symbolized the town's emergence from rural community to Victorian suburb. It housed the Odd Fellows lodge on the top floor and the Arlington Five Cents Savings Bank at ground level. Here it is shown in patriotic bunting for the town's centennial celebration in 1907. The building was demolished and replaced by a two-story structure in 1955. When "Bank Five" failed in 1991 it was taken over by Cambridge Savings Bank. (RL.)

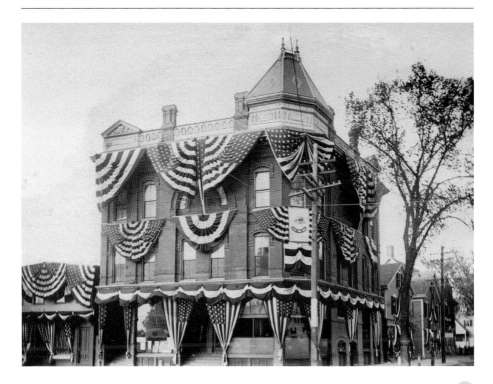

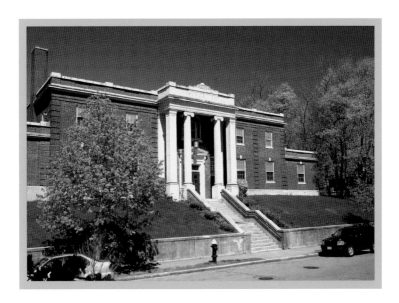

Cotting Academy was established in 1858 on land donated by William Cotting to serve as the first secondary school in town, and led to the naming of Academy Street. It joined the West Cambridge public system in 1864. After the school was abandoned for a replacement across the street in 1894, Cotting's heirs successfully sought its return. In 1923, ground was broken for the Neoclassical Masonic temple, which originally housed the Hiram and Russell Lodges. In 2005, three lodges combined as the Mystic Valley Lodge. (RL.)

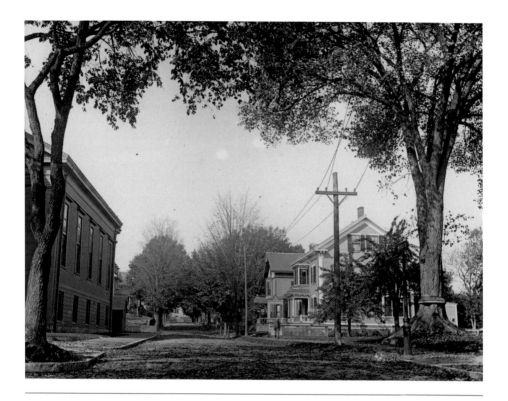

Maple Street was cut-through from Pleasant to Academy Streets in 1873. It was briefly named Church Street, perhaps because of the Pleasant Street (formerly "Orthodox") Congregational Church at left. At right are two handsome late-Victorian homes, the first of which was the 1874 church parsonage. These houses and the Swan estate (out of view) were razed for construction of the 1955 New England Telephone Company exchange building (Cram and Ferguson, architects), and the large parking lot behind it. (AHS.)

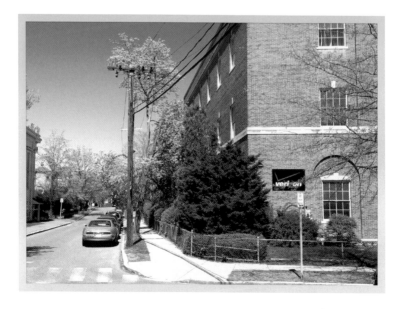

The 1845 Greek Revival mansion of John Field was repositioned on its lot at 125 Pleasant Street and remodeled as a high-style Second Empire home around 1876. By the early 20th century, Arlington's grand homes had become "white elephants." One by one they were either torn down or converted to other uses. In 1902, the Field mansion became one of several genteel rooming houses operated in the neighborhood by Mrs. Moses J. Colman, whose lodgers came here to take their meals. It was razed to make way for a modern apartment building in the 1960s. (William H. Mahoney collection.)

ARLINGTON CENTER AND VICINITY

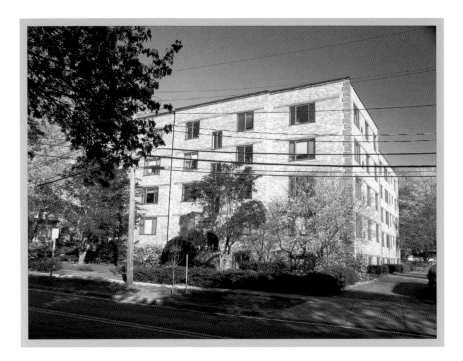

"The West Indies House" was the mansion built by William Wilkins Warren in 1840 at 128 Pleasant Street on Spy Pond. Warren left his native West Cambridge as an impoverished teenager, and returned a wealthy man after great success as a merchant in the Danish colony of St. Thomas in the Virgin Islands. The mansard roof was added around 1870 by Samuel Hicks, a later owner. The house was destroyed by fire in 1934. On the site now stands one of Arlington's most nicely landscaped modern condominium buildings. (William H. Mahoney collection.)

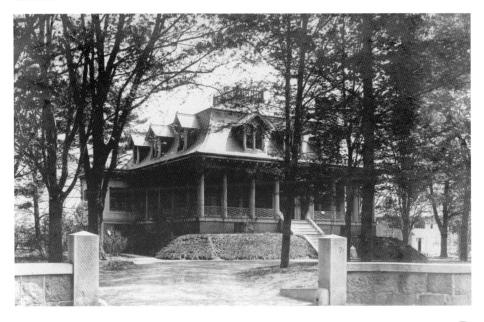

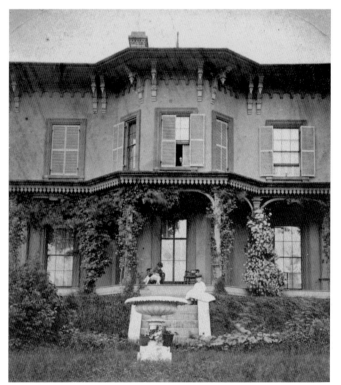

The brick mansion of Scottish immigrant John Schouler is shown in a *c.* 1870 stereograph view. Schouler established a successful calico printing factory on Mill Brook. Schouler's grand estate was among the last of its peers on Pleasant Street to be subdivided. The mansion was razed in the 1930s to make way for the homes of Monadnock Road, which are superb, high-style examples of their kind. (William H. Mahoney collection.)

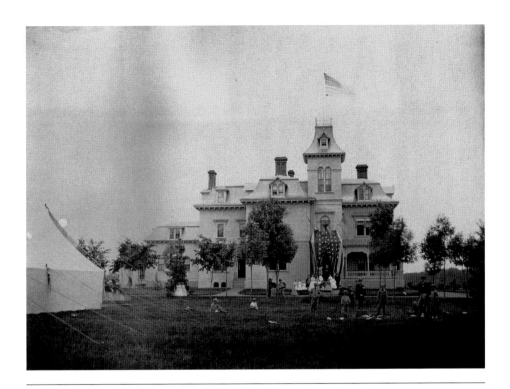

The 1865 mansion of Addison Gage on Pleasant Street was arguably the grandest home in town. Gage made his fortune in the ice-cutting and shipping business. His home overlooked Spy Pond, one of the best-known "fields" for harvesting the valuable frozen commodity. When the Gage land was subdivided in 1890, sections of the mansion were moved to create other dwellings. In its place rose such Victorian treasures as the Henry Hornblower and Charles Devereaux homes, and many others on Addison Street. (AHS.)

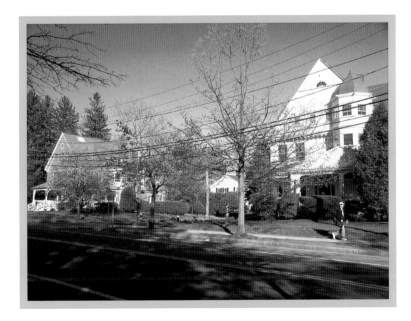

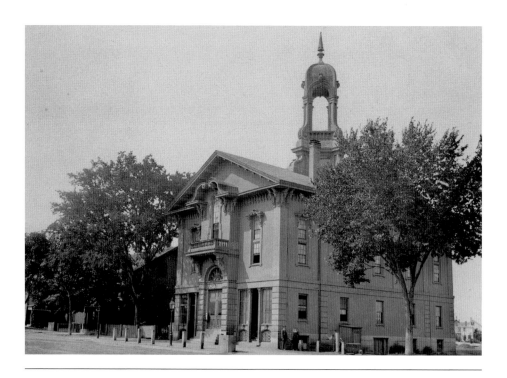

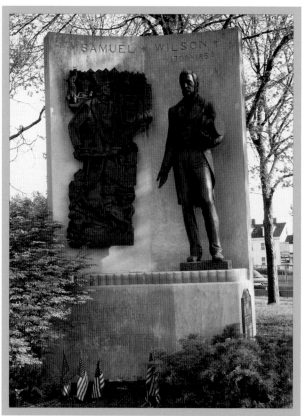

The first town hall was designed by Boston architects Melvin and Young. It opened in 1853, almost 36 years after incorporation of the municipality. West Cambridge's population had grown from 900 to 2,500 during this time. Replaced by the present town hall in 1913, the building was razed in 1960 for the realignment of Mystic Street with Pleasant Street. The 1976 statue commemorating the birthplace of Uncle Sam is the focal point of the "pocket park" that occupies part of the old "town house" site. (RL.)

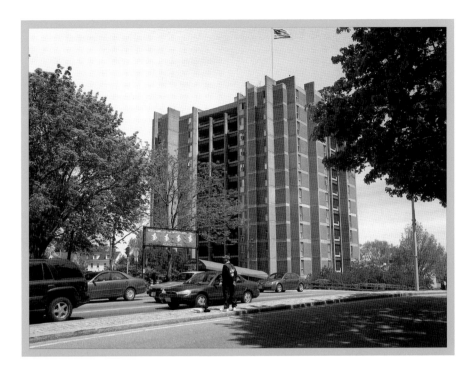

This view of the Peirce and Winn grain barn and coal sheds is appropriately serene on a summer's day. Posters advertising the circus are plastered on the board fence. This *c.* 1900 view is taken looking down what has been since 1960 the principal alignment of Mystic Street.

The looming Winslow Towers elderly housing complex was erected on the larger portion of the Peirce and Winn site in 1968. Note the banner over the Arlington Center entrance of the Minuteman Bikeway. (AHS.)

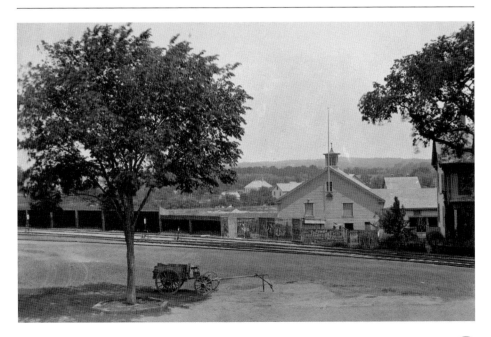

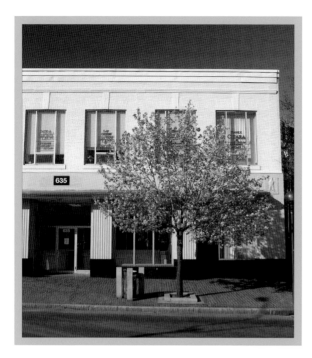

The Arlington National Bank was established in 1911 at 635 Massachusetts Avenue. This 1925 close-up shows the various Victorian embellishments on the facade of the 1898 Sherburne Block. Lion's heads, dentils, and other decoration were eliminated when the bank remodeled the entire building in the 1950s to its present stark appearance. The Coolidge Bank of Watertown acquired the Arlington National in 1972; it failed in October 1991 during the Massachusetts real estate crisis. (Jeanne Meister collection.)

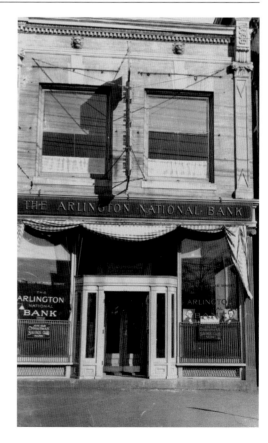

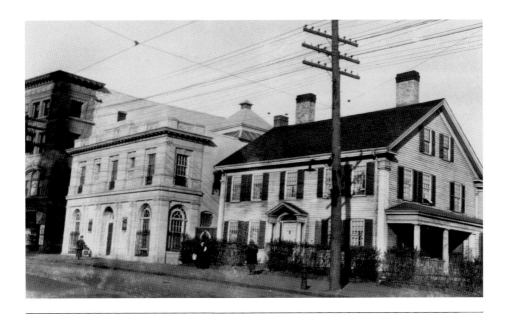

This 1925 view is looking at 645 and 655 Massachusetts Avenue. In the foreground is the 18th-century Colonel Thomas Russell House, adapted in 1916 as an "Olde New England" showroom for the Edison Electric Company. It was razed by 1930 for a commercial block. Beside it is the Menotomy Trust Company, whose cast-concrete facade obliterated the handsome yellow-brick Studio Building. The current appearance dates to its acquisition by Harvard Trust in 1948. It has been a Bank of America branch since 2004. (Jeanne Meister collection.)

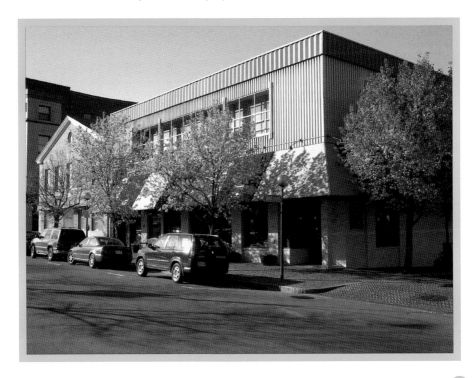

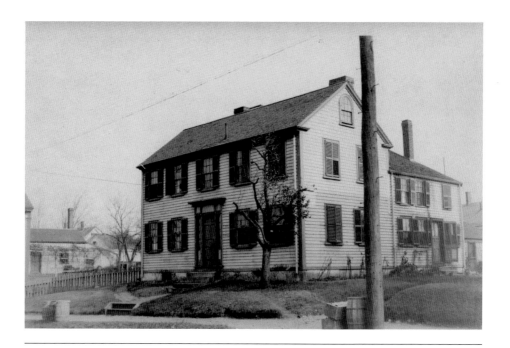

This five-bay side-gabled dwelling at 19 Water Street was a classic example of simple Federal-style architecture of late-18th-century Arlington. Although restrained in detailing, the prominent surround of the front doorway was an outstanding feature. In the mid-1800s, this was the home of William Russell, a sea captain. It was later acquired by an abutter, the Boston and Maine Railroad, and provided housing to the gatekeeper. The house was torn down around 1930 and is open space today. (Author's collection.)

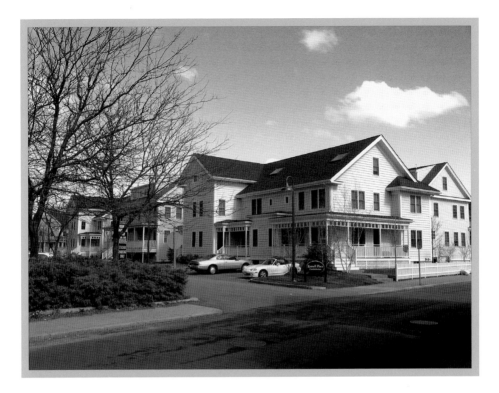

The Blanchard lumberyard at 24–40 Water Street was strategically located on the Arlington and Bedford branch line. Note the boxcars on the railroad sidings and the delivery truck heading in the direction of Russell Street. The lumber business was destroyed by fire in 1934. In 1960, a fruit-and-vegetable packing plant opened on the site, later converted to a bank check–processing facility. The Russell Place condominium replaced industrial uses with high-end residences in 2003. (Jeanne Meister collection.)

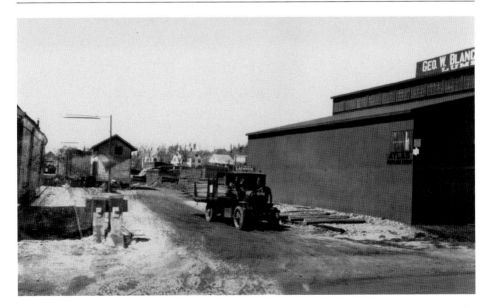

Commuters to Boston await a steam locomotive at Arlington Center, around 1948. The depot was razed in the early 1970s for parking lot expansion. Passenger service ceased on the rail line in 1977 and freight service ended in 1981. Today it is the site of the Donald R. Marquis section of the Minuteman Bikeway, which opened in 1992 as the nation's 500th rails-to-trails facility. It is reported to be the most heavily traveled such trail in the United States. (Beverly Historical Society and Museum.)

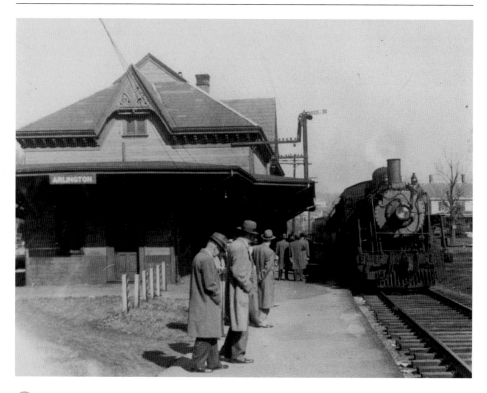

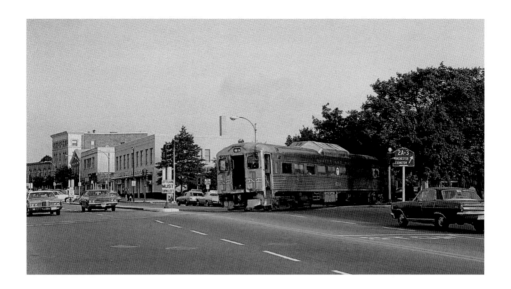

A single diesel-powered Budd railway car makes its way across Massachusetts Avenue towards Boston in 1975. There being only one passenger train inbound and outbound per day by this time, and infrequent freight service, there were no permanent gates. Ordinary traffic signals allowed the train to proceed in its turn, just like automobile traffic at the intersection. (Photograph by Alan E. MacMillan/Friends of Bedford Depot Park.)

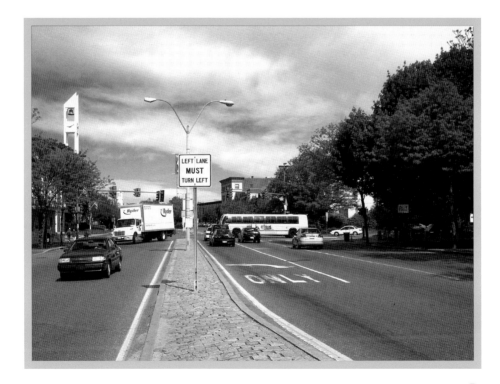

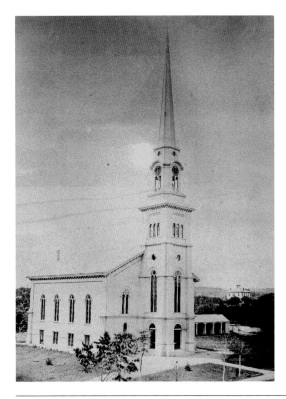

This is a rare view of the 1856 First Parish (Unitarian) Church. It was taken from an upper story of the old town hall and thus shows the church in greater context than the many other images of it. Note especially the carriage stalls to the rear of the church. Rising above the treetops is Cotting Academy. Arlington's Unitarians and Universalists merged in 1964. Their meetinghouse burned in 1975 and was replaced by a starkly modern building that was controversial both within the congregation and in the town at large. (AHS.)

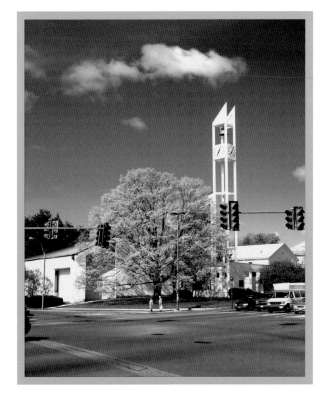

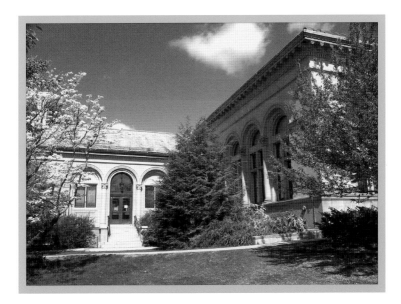

Robbins Library, completed in 1892, was a superb civic structure that was sensitively enlarged by the 1931 former children's wing, shown in the modern view, and a 1994 addition to the west. The landscaping might be described as "too much of a good thing," in that it now smothers rather than enhances the historic architecture. The mansard-roof mansion in the background of the old image belonged to Alvin Robbins. To accommodate the Winfield Robbins Memorial Garden, this dwelling was moved in 1912 and is now condominiums at 14–16 Russell Street. (RL.)

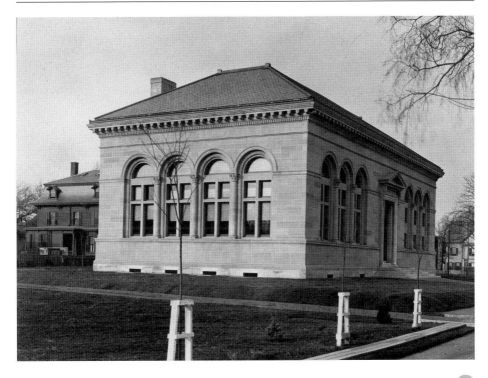

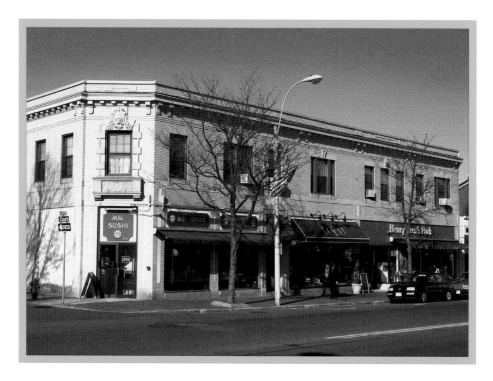

The main post office moved from the Sherburne Block into this new commercial building in 1916. The bas-relief eagle over the Court Street doorway is a reminder of its two decades as a U.S. government facility. The block is best remembered as Touraine, a ladies department store that closed in 1999 after 50 years at this location. Mr. Sushi Restaurant occupies the old post office. Tryst Restaurant and Henry Bear's Park toy store bring additional life to Arlington Center. (RL.)

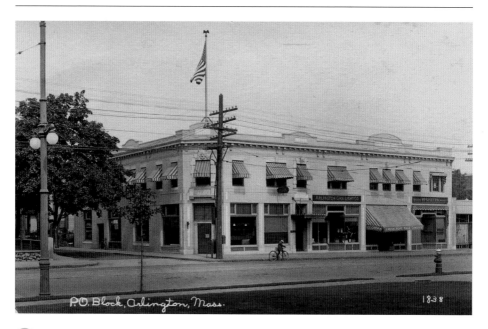

P.O. Block, Arlington, Mass.

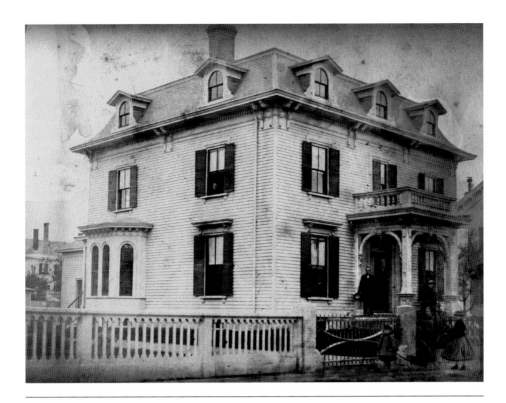

The Second Empire mansion-house of the Bryant family on Court Street was one of the most impressive in Arlington Center. In the early 20th century, it was used as a laboratory of the U.S. Entomological Service. The study and control of insects and pests was important in a vital market-gardening town such as Arlington. In 1937, the town's first purpose-built post office building was erected as a project of the Works Progress Administration. (AHS.)

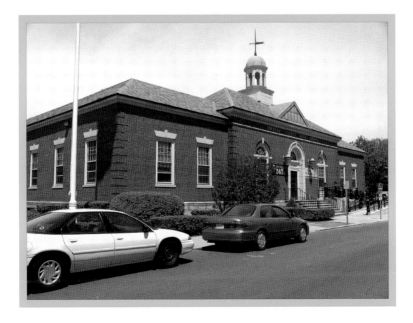

One of the first female graduates of the University of Michigan's medical school, "Dr. Miss" Julia Tolman opened a practice in Arlington in the 1870s after her internship in Boston. She eventually built her home and office at the western corner of Massachusetts Avenue and Court Street. The Arlington Co-Operative Bank replaced the house in 1935 with its Art Deco headquarters, a rare example of the architectural style in Arlington. The bas-relief sculpture above the entrance depicts homeownership for the working man. The bank has changed hands three times and is today a branch of Citizens Bank. (AHS.)

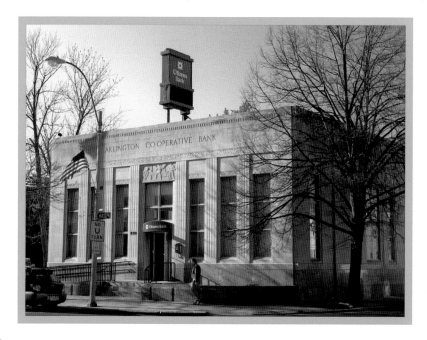

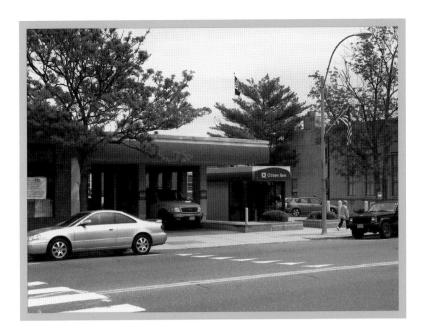

The mansard-roofed house with its charming tower was known as Liberty Cottage during World War I, serving as headquarters for military support groups. For many years afterward, it was home to the Arlington Visiting Nurses Association. The house next door had a greeting card shop at street level. The modern view shows the two-lane drive-through facility built by the Arlington Co-Operative Bank in the 1970s, and now owned by Citizens Bank. It is an unfortunate feature of an otherwise revitalized streetscape. (RL.)

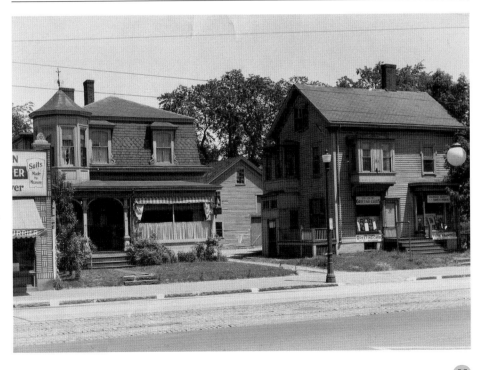

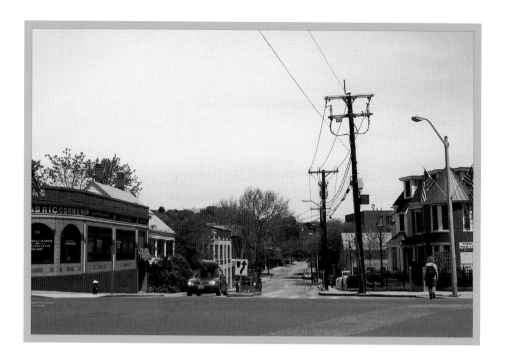

Mill Street was so named because it led to the Cyrus Cutter mill, whose acres of mill ponds extended west to today's high school playing fields. It was lined with houses on the east to Bacon Street, all of which were taken down in the expansion of Colonial Motors (later Time Oldsmobile). Today it has resumed residential use as the new Heritage Square development. Fabric Corner was originally built as a Hudson-Essex automobile dealership. (RL.)

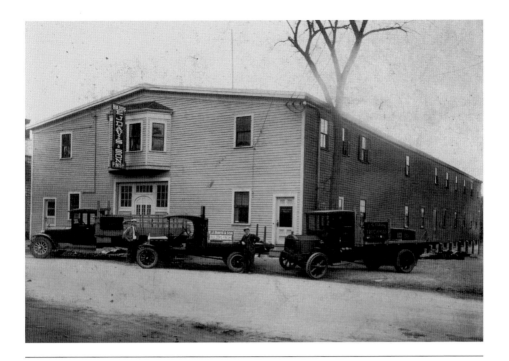

George A. Law began in the livery business in 1888 with a small barn near Walnut Street. Within a decade he was able to build a much larger building for his horses and carriages on Mill Street. The E. J. Davis and Son builder's finish business took over the site by 1928; it is likely that many homes in Arlington have built-in china cabinets, mantels, stair rails and other details furnished by this establishment. The brick replacement building now houses the sporting goods store of Holovak and Coughlin. (William H. Mahoney collection.)

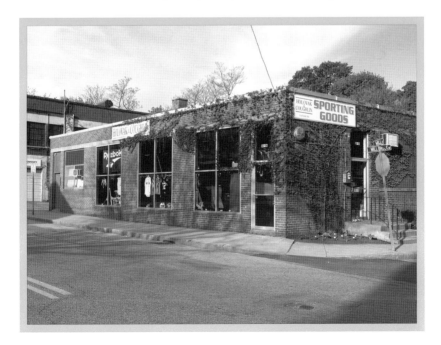

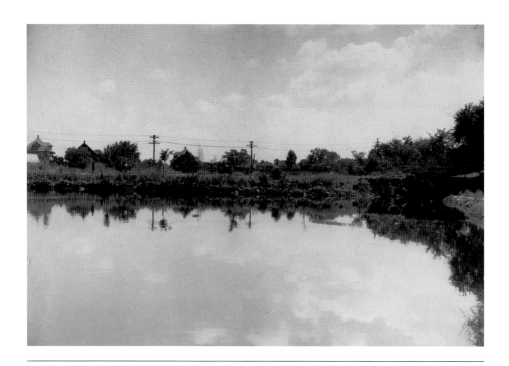

Captain Cooke's 1638 gristmill pond was in almost continuous use for over 250 years. Decades after the mill stones last turned in 1911, the pond was slowly filled to create playing fields. This section is today a practice turf for Arlington Catholic High School. The Cusack Terrace senior apartments stand on the site of the former mill buildings. The walkway atop the milldam shown in the 1935 image is now hidden by the trees. It remains part of Cooke's Hollow linear park, which extends to Mystic Street. (RL.)

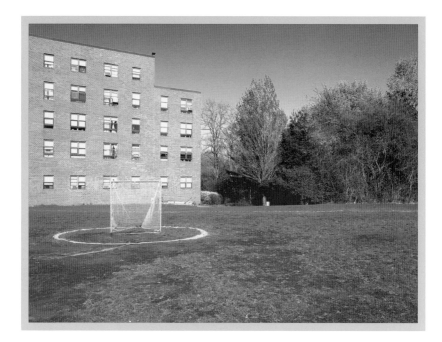

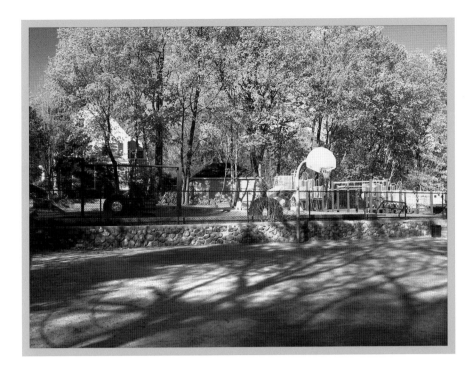

This 1925 view shows the original 1903 Parmenter School, named for Judge William Parmenter. Rapid overcrowding at the time caused one class to be held in the corridors, and others housed in the "portable" classrooms at left. When a new brick school building opened in 1927, the old Parmenter became the annex of the Junior High Industrial Arts. The building was razed in the 1950s, but the foundation wall is visible beneath the playground section of the small park that serves the neighborhood today. (Jeanne Meister collection.)

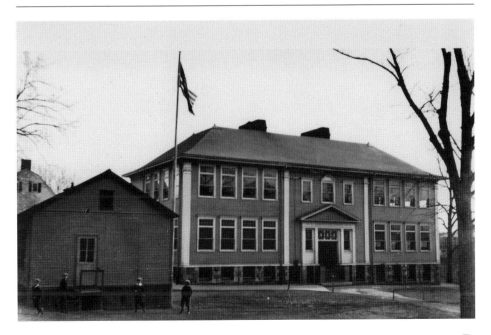

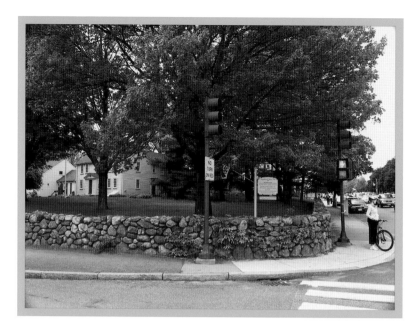

This photograph was taken in 1960, just prior to the demolition of these and other structures to restore the 1775 battlefield of the Jason Russell House. Wanzer's "White Store" is seen on the Massachusetts Avenue facade of the c. 1890 double house at the corner. The Jason Street half was home to Mr. and Mrs. Joseph Barrows. Her sister, future Metropolitan Opera contralto Madam Louise Homer, was married here in 1895 to composer Sidney Homer, whose family home was at 47 Bartlett Avenue. (AHS.)

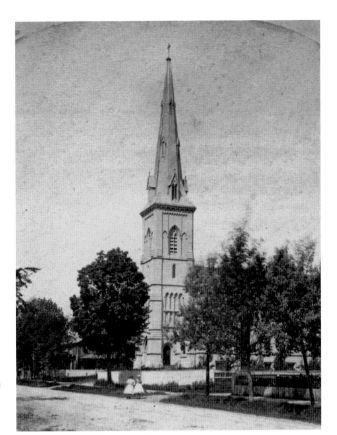

The First Baptist Church moved from its second meetinghouse (still standing at 3–5 Brattle Street) to its present site in 1853. There are many photographs of the church being consumed by fire in 1900, but this c. 1867 stereograph view is the only known to exist of the complete tower and spire. The great stone church was built on the site in 1903. (William H. Mahoney collection.)

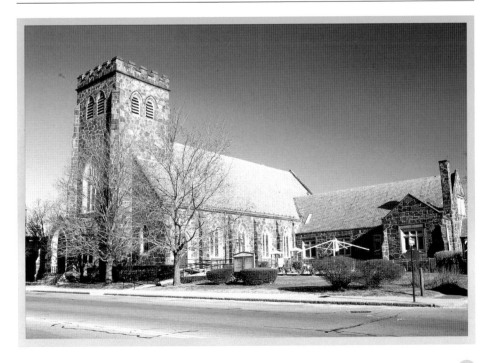

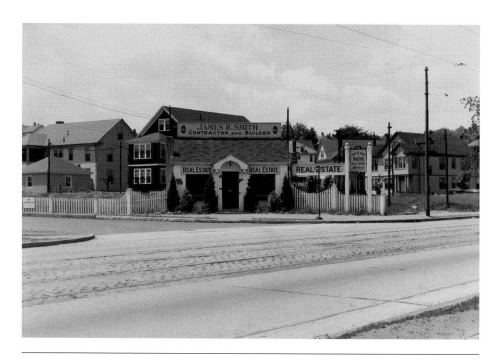

The obviously temporary real estate and construction headquarters of James R. Smith occupies the western corner of Massachusetts Avenue and Bailey Road in this c. 1929 view. Smith built and sold many of the homes in the Lockeland development. The subdivision was named for the Henry Locke farm, which it replaced. For many years this corner was occupied by a Sunoco station. In 2004, Boston Federal Savings Bank built its new branch here, which opened on the eve of its sale to what is now TD Banknorth. (RL.)

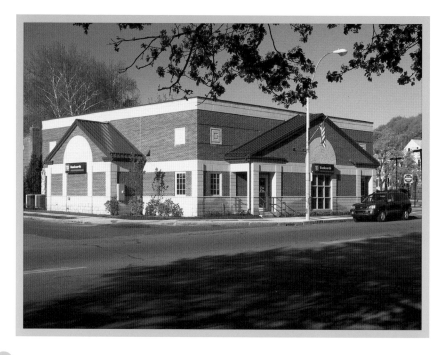

ARLINGTON CENTER AND VICINITY

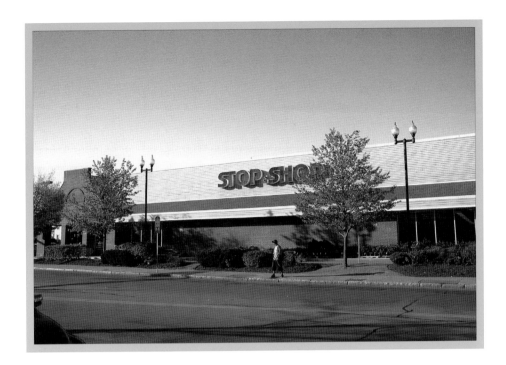

The Children of the American Revolution march in the 1974 Patriot's Day parade, past the 1959 Stop & Shop building, which was enlarged and remodeled in the 1990s. Looming above it all is the 1926 gasometer of the Arlington Gas Light Company. The telescoping tank was a navigation guide to early aviators, with "Arlington" painted on top of it in giant yellow letters, bisected by a north-pointing arrow. After years of municipal pleading with Boston Gas, the eyesore was dismantled in 1975. (Norman Hurst/Robbins Library.)

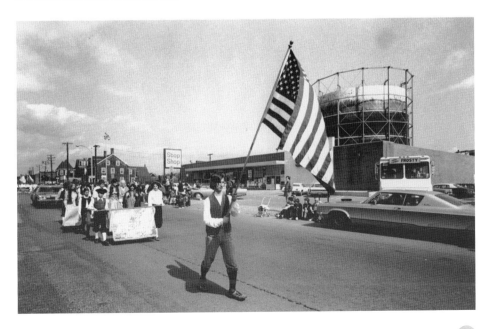

This *c.* 1840 Greek Revival double house at 921–923 Massachusetts Avenue was of a type suited to the relatively few people who did not work either as farmers or merchants. Most likely its early residents were skilled tradesmen who worked independently or at the nearby mills. The dwelling was razed in 1976 for parking at Stop & Shop. On the hill in the background stand the Thompson and Nickerson wings of Symmes Hospital, soon to be demolished to make way for condominium development. (RL.)

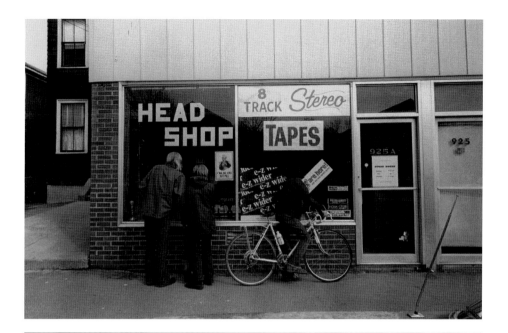

This storefront occupies what was once the front lawn of the home behind it. This type of commercial expansion was frequently seen in the 1920s all along Massachusetts Avenue. The building was divided between the butcher shop of John DeCaprio, and his father Eugenio's tailor shop. The DeCaprios were gone by 1973, by which time the store had become an in-your-face example of the soft-drug counterculture. Today it has resumed a more sedate identity as a beauty salon. (Norman Hurst, Robbins Library.)

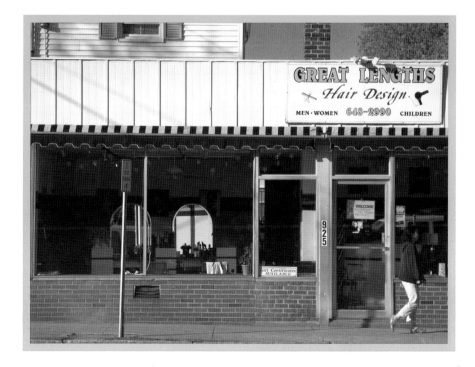

Grove Street was opened from Massachusetts Avenue as a passageway to the Welch and Griffiths saw-making mill. This 1900 image looks down towards the new overhead railroad trestle, adjacent to the Boston Chrome Plating Company. This site gave way in 1914 to the second plant of the Arlington Gas Light Company, whose buildings are listed on the National Register of Historic Places. Coal-gas was manufactured here and on Mystic Street until 1930. (RL.)

ARLINGTON HEIGHTS

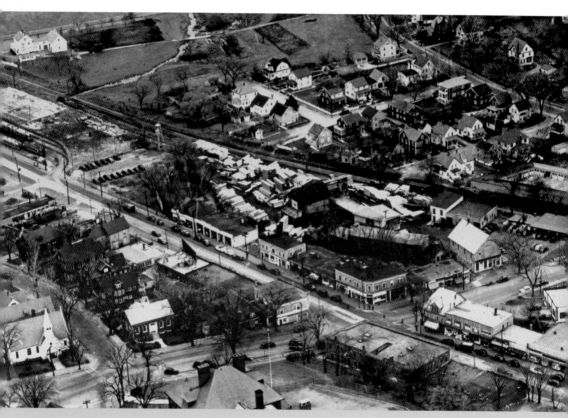

This 1948 aerial view of the intersection of Massachusetts and Park Avenues features both lost and still-visible landmarks. At left, the 1885 Park Avenue Congregational Church was replaced in 1960 by a modern sanctuary on the same site. The electric streetcar terminus is today the site of Sunrise Assisted Living. Despite many changes, the business district of Arlington Heights remains highly successful for its commercial variety in a relatively compact geography. (RL.)

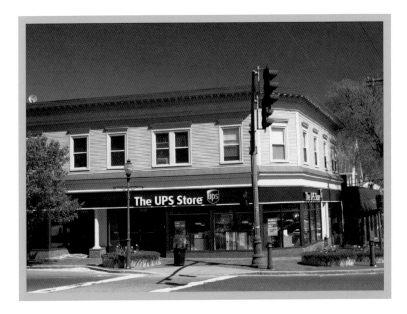

This is a *c.* 1889 view of Belcher Hartwell Provisions, at the corner of Massachusetts Avenue and Park Avenue. A handful of such small establishments could thrive within a short distance of each other in the days before self-service, when most groceries were ordered for home delivery. For decades, this building was anchored by the Beauty Corner hair salon ("that corner isn't so beautiful" was a frequent snicker). The unattractive modern storefronts have recently received a more historically sensitive face-lift. (RL.)

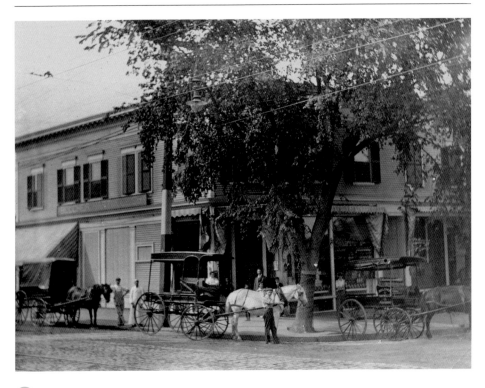

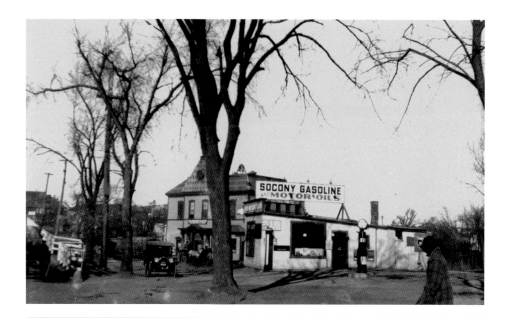

In 1925, the illuminated globe atop the pump of Park Avenue's Socony filling station stood in modern contrast to the bell on the roof of the original Locke schoolhouse. The old wooden Locke building had been moved downhill from the other side of Massachusetts Avenue to make way for its brick replacement, serving for many decades as part of Arlington Coal and Lumber; Gold's Gym now occupies the site. Sunshine Cleaners stands on the former Socony location. (Jeanne Meister collection.)

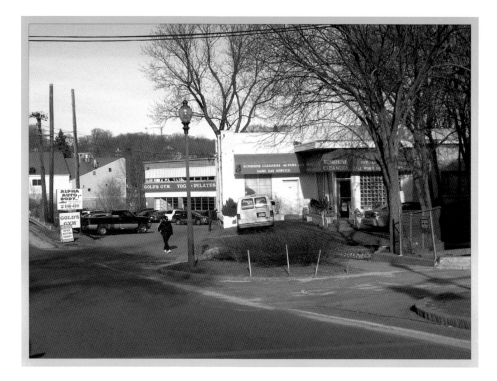

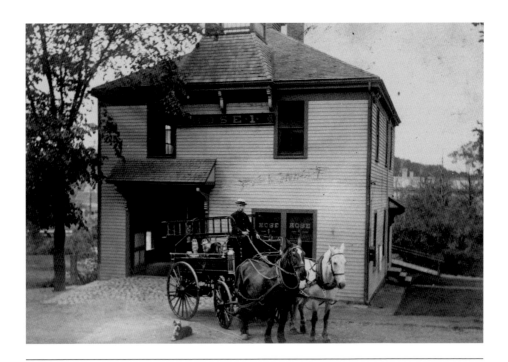

In the areas of Arlington Heights not served by hydrants, dousing fires with chemicals hauled to the scene was a practical alternative to passing buckets of well water. This firehouse stood at the northwest corner of Park Avenue and Paul Revere Road. In 1937, the Vittoria C. Dallin branch library opened on the site. It was designed by the firm of Arlington architect William Proctor. It closed after nearly a half-century of library service and today is home to the Arlington cable television studios of Comcast. (RL.)

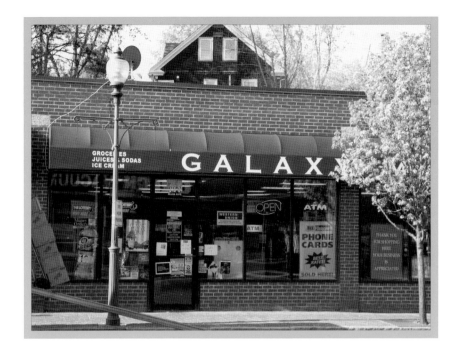

Hardware stores in Arlington have perhaps been the most successful at surviving for generations. Wanamaker's was established in Arlington Heights in 1923 and relocated a few times as it expanded to its present two-story location at the corner of Massachusetts Avenue and Davis Road. Here it is shown in the 1940s in previous quarters at 1350 Massachusetts Avenue. Today a convenience store occupies the space. (Mark Wanamaker collection.)

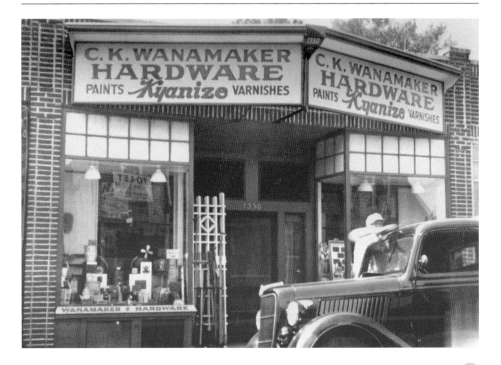

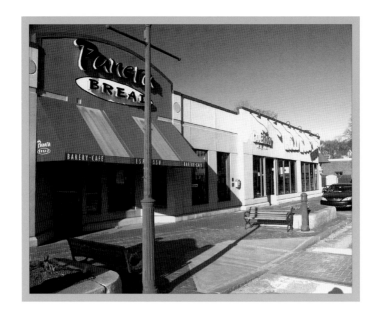

Streetcar service was extended from Academy Street to a new terminus in the heights in 1889. The vintage image dates to no earlier than 1897, as one sign advertises connections to Winchester on the Mystic Street line. The Massachusetts Avenue trolley line was entirely replaced by buses in 1955. After the streetcar barns were razed, the site continued in use for public transportation operations. Today there is a new commercial block that houses an outlet of the popular Panera bakery-café chain. (William H. Mahoney collection.)

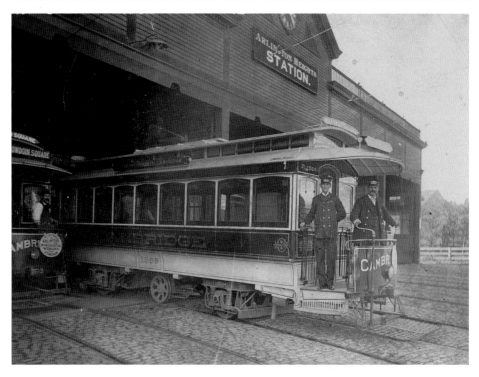

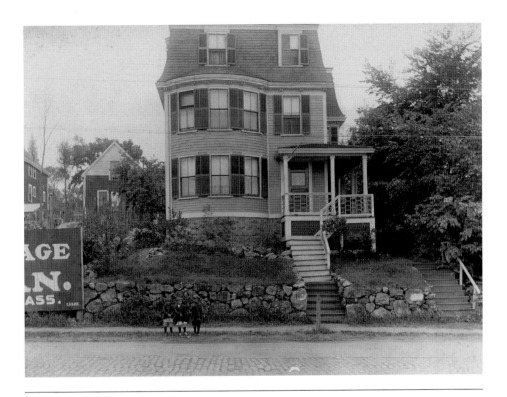

This home appears to have been moved from an unknown location to 1530 Massachusetts Avenue on the Lexington town line around 1910. This may explain its unusual architecture, combining a flared mansard roof (characteristic of the Second Empire style of the 1860s) with a two-story bow-shaped projection on the front facade (more typical of later Colonial Revival styles). This house still stands, but the decorative detailing shown in the older image has been either shorn or masked by the application of synthetic siding. (RL.)

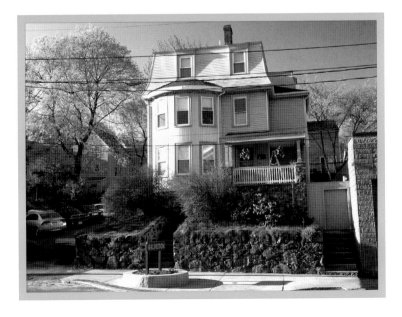

When the Lucy A. Whitney house was built in 1897 at 274 Park Avenue, it stood in relative isolation in the vicinity of Park Circle, which offered superb panoramic views and refined country living. Note the charming rusticated fence that surrounded the handsome cedar-shingled home. This once-prominent home now sits amidst a densely built streetscape, its original detailing hidden beneath aluminum siding. The property recently has changed hands and may be restored to its former charm. (RL.)

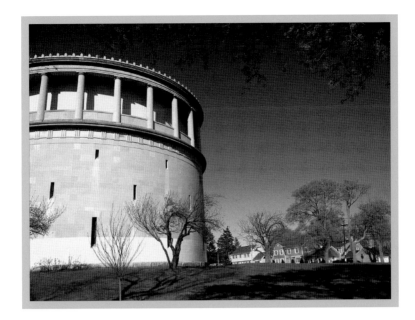

Although the town offered municipal water service after construction of the Arlington Reservoir in 1872, the gravity-fed system could not accommodate residents at higher elevations until this 1894 standpipe was erected at Park Circle. The lone building behind it is the Outlook Spa Hotel, which opened in the 1870s. It was razed in 1990 for the construction of three new homes. The utilitarian standpipe was replaced in 1924 with the monumental water tower by Arlington architect Frederick Low. It was inspired by the visit of its donors, the Robbins sisters, to the Doric ruins at Assos in the Greek Isles. (AHS.)

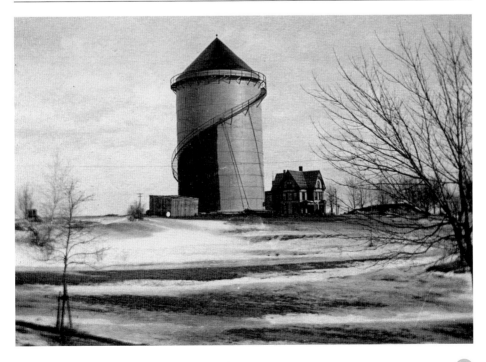

The Ichabod Fessenden house was a Colonial-era dwelling that stood on the west side of today's Fessenden Road. It faced a section of Massachusetts Avenue that was known as High Street, until the entire length of the old road to Concord was renamed to Arlington Avenue from 1867 until 1894. Like most pre-Revolutionary structures in town, the Fessenden house was razed in the early-20th-century march of progress. (AHS.)

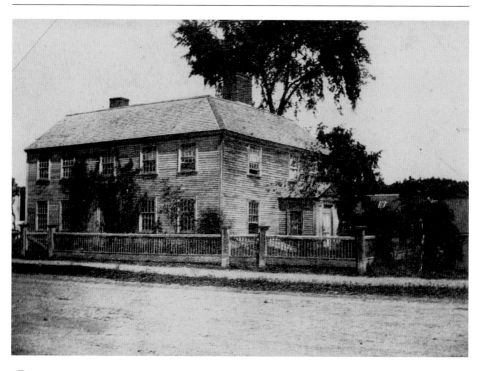

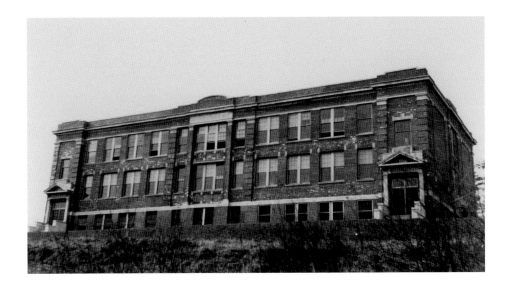

The Junior High West was built in 1921 on the site of a former stone and gravel quarry. It was the first purpose-built school in Arlington after the three-year (grades seven through nine) junior high was introduced to replace the eight-year grammar and four-year high school configuration. Renamed to honor long-serving principal A. Henry Ottoson, the building now houses grades six though eight as the town's only middle school. Modern additions have hidden the original main facade overlooking Appleton Place. (Jeanne Meister collection.)

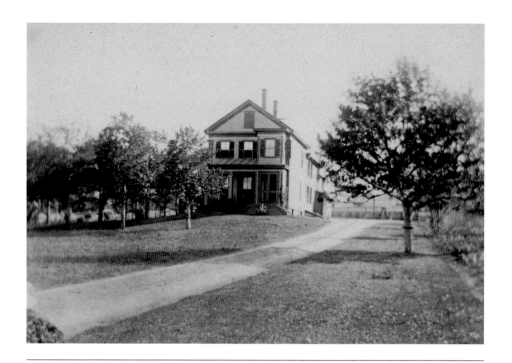

The Henry Swan house is shown in this 1882 image by his nephew, B. Frank Swan. The house faced a section of Gray Street then known as Prentiss Street, and the driveway is today's Coolidge Road. It led to a commercial slaughterhouse, isolated high on the hill in the mid-19th century. Swan was a successful poultry merchant at 18 Faneuil Hall Market in Boston. (William H. Mahoney collection.)

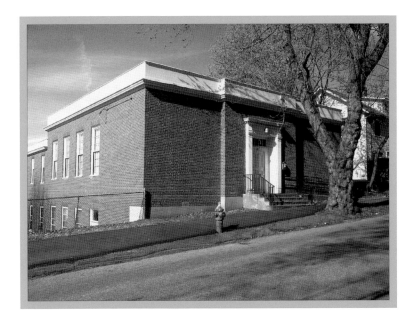

The Arlington Heights Methodist Episcopal Church was the first of the denomination to gather in Arlington. The congregation built this picturesque shingled church on Westminster Avenue in 1907. It was demolished in the 1950s to make way for the brick Colonial Revival auditorium shown in the modern view. In 1994, the heights church merged with Calvary Methodist, established in East Arlington in 1922. Today the church is home to the Arlington Nursery School. (RL.)

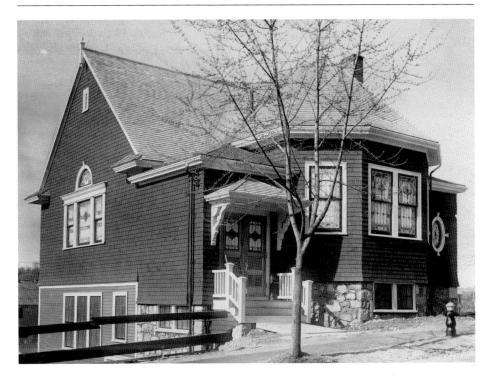

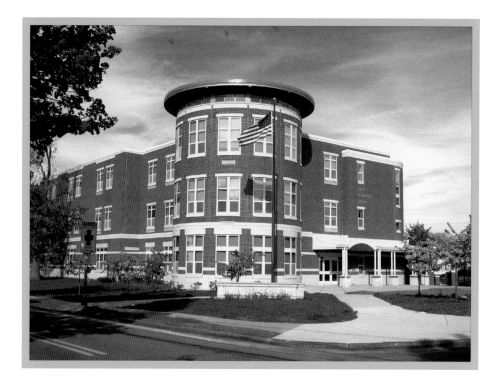

When Summer Street was extended from Brattle Street to the Lexington line in 1915, waves of residential development in the Adams Square and Crescent Hill sections of town soon followed. To serve these new neighborhoods, the Peirce Elementary School opened in 1923. It was torn down in 2001 and replaced by a modern building. The stone lintel above the main entrance of the old building was preserved as a landscape feature after the new school welcomed back students in 2003. (Jeanne Meister collection.)

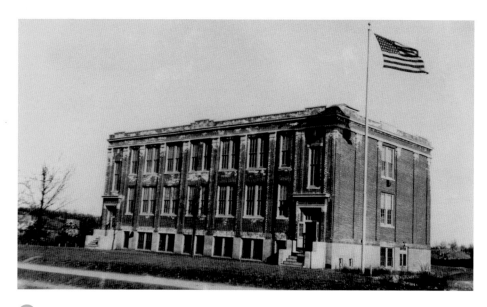

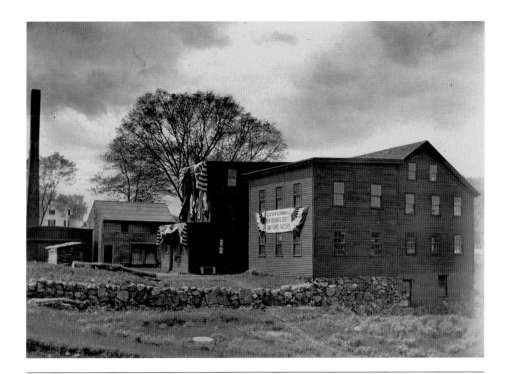

The Clinton Schwamb picture-frame mill is bedecked in patriotic bunting to celebrate Arlington's centennial as a town in 1907. This is an unusual view of the east side of the main mill building, which was possible to capture before the houses on Locke Street were built. Saved in 1969 by the late Patricia C. Fitzmaurice, the Old Schwamb Mill is today a working museum. Above the old boiler house and lumber-drying building (the latter home to Shaker Workshops today) rises the very sensitively designed Watermill Place condominium. (Schwamb Mill Preservation Trust Collection.)

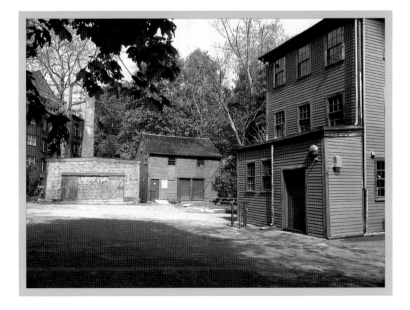

The Francis Locke home at the western corner of Forest Street and Massachusetts Avenue was built around 1719. It originally was a two-story house with an attached single-level store, which was later raised to create a double-house. Capt. Benjamin Locke of the Menotomy Minutemen once lived here. In the modern view stands the 1920s business block that was one of many that transformed Massachusetts Avenue into a commercial corridor during the residential building boom of the era. (AHS.)

CHAPTER 4

MYSTICSIDE

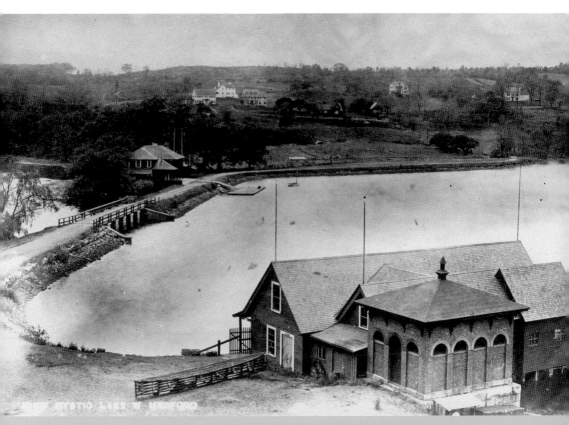

This *c.* 1910 vista of the Upper Mystic Lake shows the fine homes which dotted the hills of what would be known as Morningside. The 1899 Medford Boat Club stands on the Arlington shore, at the far end of the dam. Adjacent to it are the sloping vegetable fields that would soon become the Interlaken subdivision. (William H. Mahoney collection.)

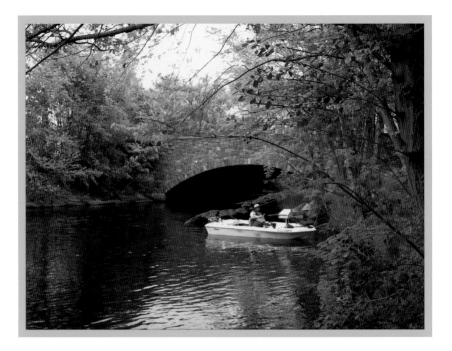

The *c.* 1898 image shows the Mystic River in it natural tidal state, crossed by the Medford Street Bridge built a few years earlier. Work began in 1905 to relocate and deepen the river's channel and it became an exclusively freshwater stream when the Cradock Dam was completed in Medford Square in 1910. The Arlington section of the river is visible only in winter because of too-dense tree plantings. The stone arched bridge shown in the modern view was built in 1937. (Medford Public Library.)

This *c.* 1885 view of the Mystic River was taken from the Medford Street Bridge looking north towards the Mystic Lakes. Note the protruding channel markers that were a much-needed safety feature for boaters at low tide. The straightened and deepened river as it appears today presents an almost generic, sterile landscape by comparison to the more varied scenery from the tidal era. (Medford Historical Society.)

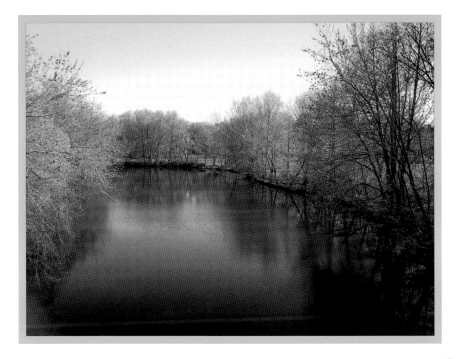

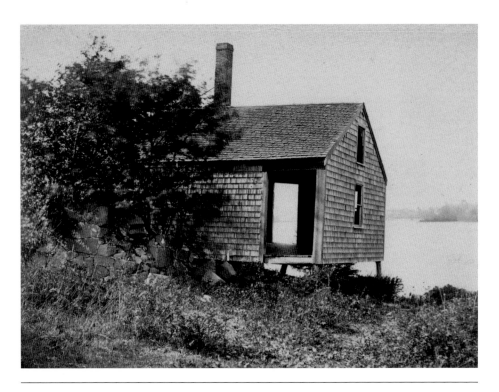

During a smallpox epidemic in 1872, the town hastily built a quarantine hospital on a remote section of Mount Pleasant Cemetery, on a bluff overlooking the Mystic Lakes. The "pest house" was quickly abandoned as can be seen in the 1882 photograph, and it burned in 1884. The Yarumian family headstone, shown in the modern view, is one of the most distinctive in this section of Mount Pleasant. (William H. Mahoney collection.)

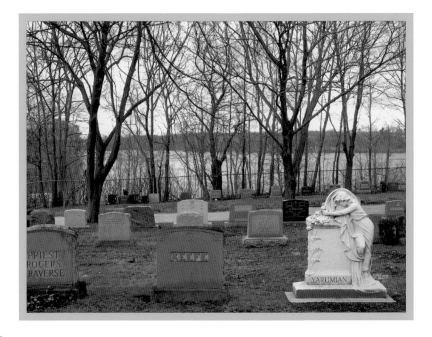

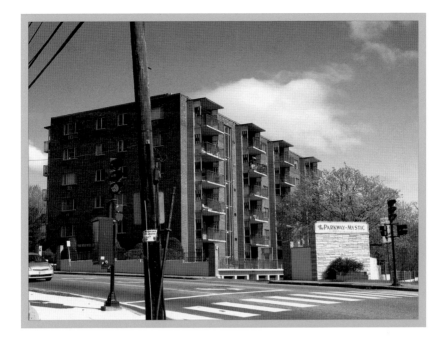

The 1948 photograph shows the new traffic signals at the intersection of the Mystic Valley Parkway, Mystic, and Summer Streets. The late-Victorian home and medical office of Dr. Lydia Holmes was torn down for construction in the 1960s of the Parkway-Mystic apartments, shown in the modern view. This high-rise was one of so many that sprouted in Arlington in the 1960s and early 1970s, that the town declared a temporary construction moratorium to enable more thoughtful development planning processes going forward. (Boston Herald.)

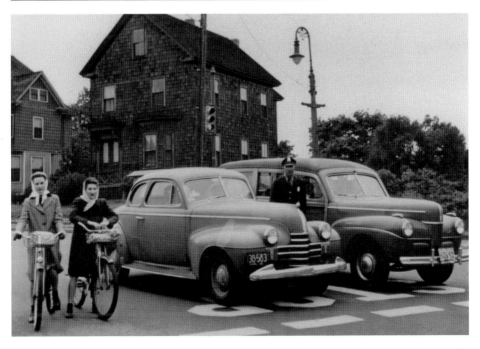

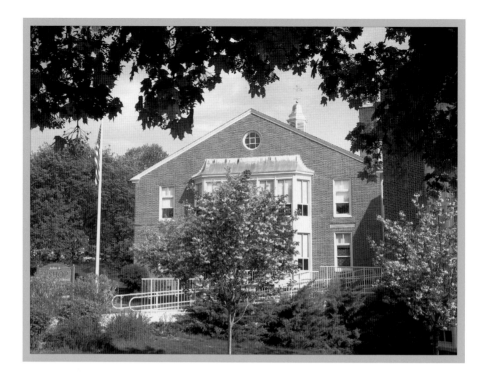

The hothouses in the vintage image were among several located at the Crosby Farm, which was the last of the large market gardens to surrender to suburban development. Famous for its "Arlington Pure White" variety of celery, the Crosbys sold out in two waves in the 1930s and 1950s. The modern view shows the Bishop Elementary School, which opened in 1950 on the former farmland. It was the first school to serve the Mysticside section since its annexation from Charlestown over 100 years earlier. (AHS.)

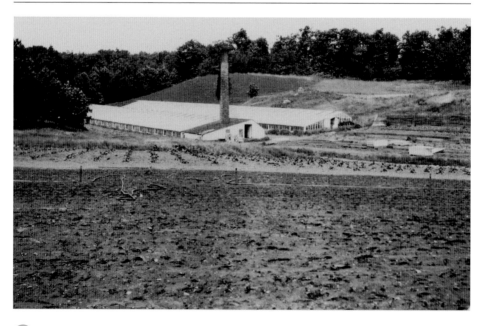

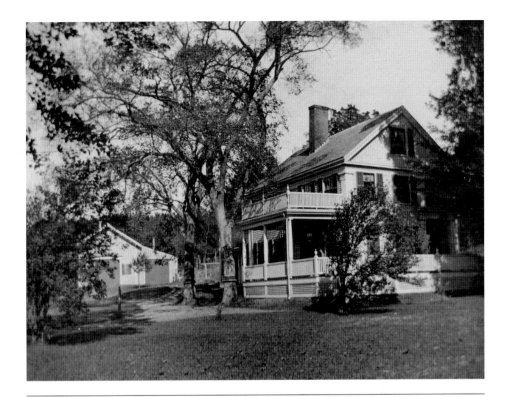

This Greek Revival home at 298 Mystic Street once belonged to John S. Crosby, whose family operated an extensive market garden, along with henhouses, a piggery, and a retail farm stand. Generations of Crosbys resided here until the last of the farm was sold for development in the 1950s and the family moved its agricultural operations to Maine. Once bucolic, Mystic Street today is busy Route 3, and the Crosby house must now seek quiet behind a tall fence. (AHS.)

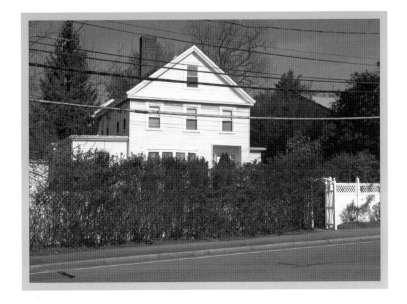

In 1870, the highly successful sugar and tea merchant Nathaniel C. Nash retired to this fine mansion at 308 Mystic Street. In 1882, it was acquired by wholesale grocer Howard Spurr, who amassed a fortune with the popular Revere brand roasted coffee. After the Spurr family departed, the home was used by a Roman Catholic order of Franciscans. Following World War II, the estate was subdivided for suburban ranch homes. (AHS.)

Built in 1845, Ridgemere was the summer home of Boston publisher Thomas Niles, whose authors included Louisa May Alcott. The angle of this view features the south portico in the foreground, and allows one to see the mansion in relation to the fanciful belvedere that overlooked the Mystic Lakes. Ridgemere, like many of Arlington's grand mansions, was razed in the 1930s. The post-World War II residential development of Beverly Road occupies the 21 acres of the old estate. (AHS.)

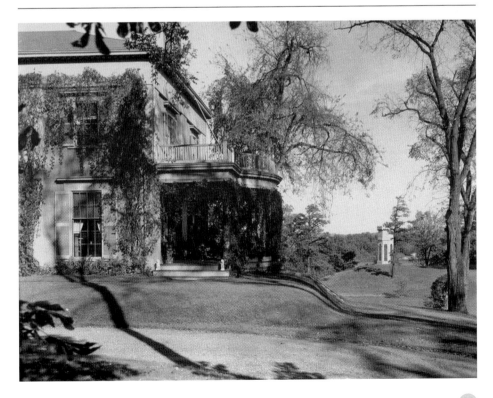

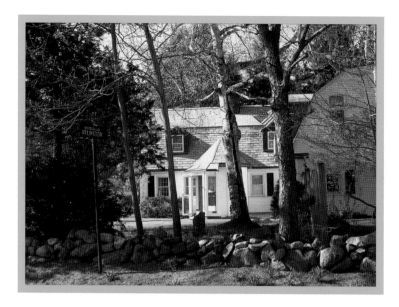

This is the early-19th-century home of Abel Pierce, who established the large farm on Oak Street (now Hutchinson Road), which passed to his son Oliver. Augustus Pierce was the last generation to operate the 32-acre spread (20 of which were for livestock pasture), well-into the 1920s. When the farm was later subdivided, the home at the corner of Lantern Lane, shown in the modern view, echoed some of the architectural lines of the old farmhouse. The stone projecting in the front lawn is an old West Cambridge-Winchester boundary marker. (RL.)

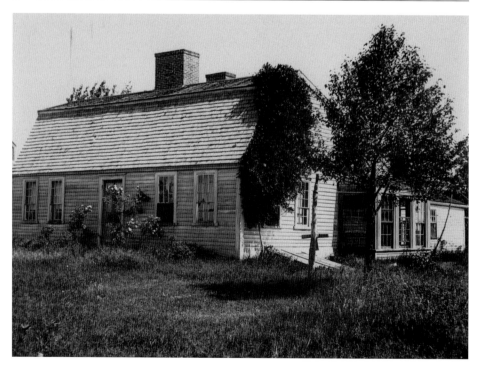

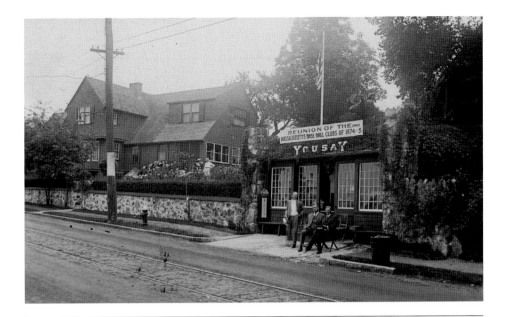

YousaY cottage on Mystic Street was a sort of clubhouse for grownups, built in 1909 by Moxie partner Freeman Young, whose home is seen at left. It enjoyed fine views of the Upper Mystic Lake and was itself a sightseeing attraction for passengers on the trolley cars going to and from Winchester. YousaY featured a garage at street level with a turntable to reposition automobiles in the days before reverse gear. The country road of the past is today's busy Route 3, but the garage and the picturesque cottage remain. (RL.)

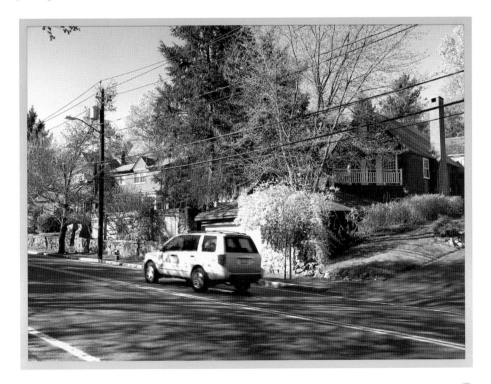

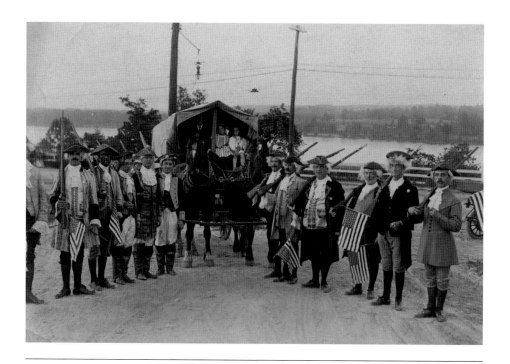

These local gents depict the Minutemen of Menotomy, who captured a British supply wagon on April 19, 1775. They were featured in the 1913 Arlington Pageant, which was performed on the banks of the Upper Mystic Lake. The man in blackface portrayed David Lamson, a biracial patriot. Note the open vista of the lake as seen from the junction of Old Mystic and Mystic Streets. In the modern view, established residential neighborhoods form a dramatically different backdrop. (William H. Mahoney collection.)

The *c.* 1730 Wyman farmhouse stood at 352 Mystic Street. Its barn stood across the street from the dwelling. The Wyman lands extended from the shore of the Mystic Lakes to high on the hill behind the house. By the mid-1800s, the farm was owned by Isaac Huffmaster. Following residential subdivision around 1915, the charming bungalow at 4 Upland Road was built, and a few years later the farmhouse was razed for the home shown in the modern view. Its side yard recently has been staked for a new building lot. (RL.)

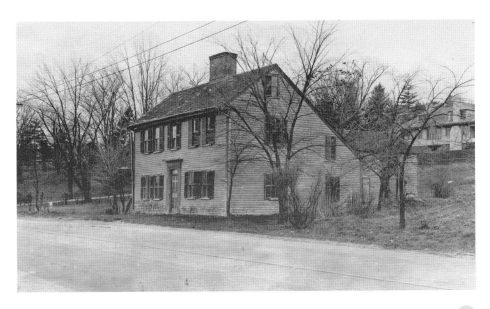

www.arcadiapublishing.com

Discover books about the town where you grew up, the cities where your friends and families live, the town where your parents met, or even that retirement spot you've been dreaming about. Our Web site provides history lovers with exclusive deals, advanced notification about new titles, e-mail alerts of author events, and much more.

MADE IN THE

Arcadia Publishing, the leading local history publisher in the United States, is committed to making history accessible and meaningful through publishing books that celebrate and preserve the heritage of America's people and places. Consistent with our mission to preserve history on a local level, this book was printed in South Carolina on American-made paper and manufactured entirely in the United States.

This book carries the accredited Forest Stewardship Council (FSC) label and is printed on 100 percent FSC-certified paper. Products carrying the FSC label are independently certified to assure consumers that they come from forests that are managed to meet the social, economic, and ecological needs of present and future generations.

FSC

Mixed Sources
Product group from well-managed
forests and other controlled sources

Cert no. SW-COC-001530
www.fsc.org
© 1996 Forest Stewardship Council

Find Your Place in History.